IMAGES
of America

CLIFTON FORGE

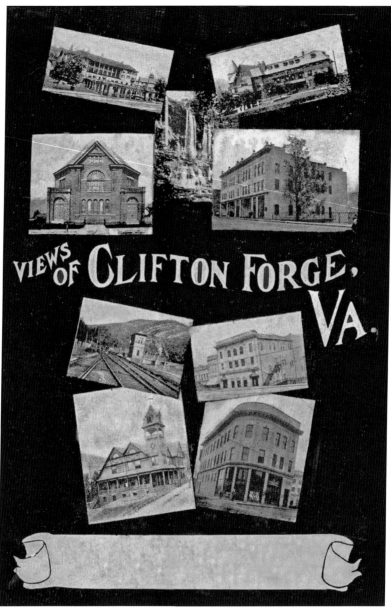

VIEWS OF CLIFTON FORGE, VA.

This early postcard, which is dated from around 1910, features an interesting mix of railroad and civic structures from Clifton Forge. Clockwise from the top left are the Gladys Inn and passenger station (1897), the Chesapeake & Ohio (C&O) Hospital (1897), the Alleghany Building (1910), the Masonic Theater (1905), the Boxley Building, the Railroad YMCA (1898), James Division (JD) Cabin and Rainbow Rock, and Clifton Forge Baptist Church (1896). (Courtesy of Jeff Johnson.)

ON THE COVER: In the late 1890s, citizens of Clifton Forge enjoy a Fourth of July parade. The parade is headed east on Main Street. The Lavin Building can be seen on the right, and in the distance on the right is the Moody Building. One will notice that the Masonic Theater has not been built. Today, most of the other buildings seen in the photograph are gone. (Courtesy of Horton Beirne, *Virginian Review*.)

IMAGES
of America

CLIFTON FORGE

Rick Tabb and Josephine Dellinger
on behalf of the C&O Historical Society
and the Clifton Forge Woman's Club

ARCADIA
PUBLISHING

Published by Arcadia Publishing
Charleston, South Carolina

Printed in the United States of America

Library of Congress Control Number: 2011925046

For all general information, please contact Arcadia Publishing:
Telephone 843-853-2070
Fax 843-853-0044
E-mail sales@arcadiapublishing.com
For customer service and orders:
Toll-Free 1-888-313-2665

Visit us on the Internet at www.arcadiapublishing.com

CONTENTS

Acknowledgments 6

Introduction 7

1. From Village to City 9

2. The Downtown 23

3. The Railroad 51

4. The Community 73

5. The Neighborhood 99

6. The Journey Continues 119

ACKNOWLEDGMENTS

The Clifton Forge Woman's Club and the Chesapeake & Ohio Historical Society (COHS) are grateful to many people who have contributed time and photographs to this book. Special recognition must be given to Jean Ann Higgins Manner, who so graciously gave her time, contributed her extensive knowledge of the history of Clifton Forge, and shared her lifelong photographic talent. We are also grateful to Mac Beard for his editorial experience, his technical knowledge, and his patience, and Dr. Edward Allen for help, patience, and technical support. Many images from the archives of the C&O Historical Society have been used, and we are grateful for them. We also appreciate so very much Marilyn Woods for taking her time to edit the text.

We want to thank Charles and Karen Hammond (CKH), who so willingly shared their extensive collection of photographs. We also want to extend a special thank you to Wanda Whiteside Walton, Thomas W. Whiteside Jr., Sharon Whiteside, the late Edith Craft Whiteside, and the late Edgar Fulton Craft for the splendid collection of images from Craft Studios (CS).

We are grateful to the following members of the community and the organizations who have been willing to share their treasured photographs: Horton Beirne of the *Virginian Review* (HB), Clifton Forge Public Library (CFPL), the Clifton Forge Fire Department (CFFD), the Alleghany Historical Society, Clifton Forge Main Street, Alleghany Highlands Arts and Crafts Center, Dabney S. Lancaster Community College (DSLCC), Bari Ballou, Anna May Gilbert, Elaine Finestone, Oscar Hunt, Jeff Johnson, Jimmie Houff, Don Carter, Nancy Little Rutherford, Ettrula Clark Moore, Catherine Rule Bryant, Lillie Hughes, Gretel Anderson, Julia Bradley, JoAnn Gideon, Debby Faulkenbury, Ronnie Jones, Vivian Sutphin, Nancy Cahoon Gilbert, Kelly Slusser, Bob Slusser, George "Chip" Snead, Delores Turner of the First Christian Church, Ann Drewry, Richard Miller, Paul and Joan Higgins, John Hayes, Ed Dean, Don and Johnette Roberts, Diana Kling-Smith, Carol Davis, Mary Gray Dellinger, and others in Clifton Forge who love this town.

INTRODUCTION

Travel west from Richmond, Virginia, on US 60, the Midland Trail, 160 miles to where US 220 North from Roanoke intersects, and you will find the town of Clifton Forge, elevation 1,065 feet. It is nestled in the valley of the Jackson River, just west of where this rushing mountain course joins the placid Cowpasture River to form the great James. Located in what is called the Alleghany Highlands, it is surrounded by verdant mountains that rise up sharply hundreds of feet. The town extends north from the river plains up into the hills. Between the town and the river lies the railroad, which runs east and west. These four elements—the river, the mountains, the road, and, most significantly, the rail—shaped the growth and development of this small but lively and active town.

The land where Clifton Forge is today was granted to Lord Botetourt, governor of Virginia, from 1768 to 1770, by King George III. The earliest settlers arrived here in 1770, when the area was then the frontier of the west. Robert Gallaspy was given a grant of 200 acres on the west side of Smith Creek and the north side of the Jackson River. Over the next 40 years, the land changed hands several times. In 1837, Andrew Williamson and his wife, Jean, arrived from Scotland and took up residence in a house originally built by Robert Gallaspy. The tiny settlement became known as Williamson after the large family that owned the land for 30 years. This name was used until the 1880s. The area was primarily agricultural and grew slowly, partly due to neighboring Covington being the more established community, a trading and transportation center, and the county seat.

The earliest industry in the area was iron mining and smelting, which created pig iron that was shipped down to Richmond in bateaux (long, flat-bottomed boats that could negotiate whitewater rapids) on the Jackson and James Rivers. The area had the perfect combination of rich iron ore deposits, forests for fuel and charcoal, water for power, and limestone. At its peak, the area had 11 major iron furnaces. About a mile southeast of town, a furnace was established in 1846 in Rainbow Gap and named Clifton after a family farm in Rockbridge County. The large stone structure, part of which still stands today, became a landmark, and people began to refer to the area as Clifton Forge.

The railroad arrived in 1857. The Virginia Central came from Staunton in the east, over North Mountain, and then through Goshen and Millboro. It traveled along the Jackson River to terminate at a spot called Jackson's River Station, located a few miles west of town near where Oakland Church stands today, just 10 miles short of its destination of Covington. Due to lack of funds and the interference of the Civil War, the railroad did not extend any farther until 1869. Collis P. Huntington of transcontinental railroad fame purchased the railway, named it the Chesapeake & Ohio (C&O), and pushed it westward. In 1873, the railroad was completed to Huntington, West Virginia, and continued to expand. The Richmond & Alleghany Railroad, which was laid on the towpath of the James River and Kanawha Canal and entered Clifton Forge from the south, was merged into the C&O in 1889.

Of any single element, the railroad was to have the greatest effect on the development of Clifton Forge. It was strategically located at the intersection of three major rail paths: the line up the mountain to Staunton, which connected the population centers of Virginia; the line down the river to Richmond, which gave it a down-grade, water-level route for shipping heavy loads; and the line west up and over Alleghany Mountain to the great coal fields. Clifton Forge was an ideal place for a division point and the facilities to support it. The early shops were established in the Smith Creek Yard area and included a roundhouse, freight house, and other facilities. In 1889, larger facilities were needed, and the shops were moved to West Clifton Forge, where their remnants are today. This facility was the second largest on the C&O and was capable of performing the heaviest and most sophisticated of repairs.

In 1884, state charter established the town, and the name changed officially to Clifton Forge. The railroad bought much of the land in town and established the C&O Development Corporation, which sold lots. In the early boom years, speculators bought and sold lots feverishly. The town grew quickly, and the railroad brought many jobs. At its peak, the railroad employed as many as 3,000 workers between the shops, yard, and road operations. Railroad jobs were among the highest paying at the time and led to the establishment of a strong, affluent middle class. The railroad also brought many innovations to the community, such as the Railroad YMCA and the C&O Hospital.

The period from 1890 to 1920 saw the building of many of the town's landmarks and institutions: the Masonic Theater, the post office, town hall, the Gladys Inn, the Alleghany Building, and our many beautiful churches. The railroad made Clifton Forge a bustling and cosmopolitan place. With 16 passenger trains arriving daily, it was a hub of activity, connected almost instantly to the great cities of the East and West. A *New York Times* newspaper would arrive the same day it was printed, and a bushel of oysters would arrive the same day it was harvested. At its peak around 1930, the population of the town was over 6,800 and boasted many restaurants, banks, clothing stores, jewelry stores, automobile dealerships, hardware stores, dime stores, hotels, a bookstore, and a department store. It had a fine school system and was the western hub of the Clifton Forge–Waynesboro telephone company. It was truly deserving of its motto: "Busy-Scenic-Friendly."

Railroad employment peaked around 1950. With the coming of the diesel locomotive and other laborsaving innovations, employment declined steadily over the next 30 years. In 1987, the shops closed completely, causing a severe economic blow to the community. A period of decline followed when many businesses and stores gradually closed, leaving a commercial district with many empty storefronts.

However, the citizens of Clifton Forge are a strong and resilient bunch. They never gave up, and today, the town is experiencing a renaissance. It is trading its industrial past for a future based on its true natural resources: scenic beauty, railroad heritage, cultural appreciation, and location on a major transportation corridor. Pioneer establishments, such as the Alleghany Highlands Arts and Crafts Center, the Club Car restaurant, Country Garden Florists, Clifton Forge Main Street, Northwest True Value Hardware, and the Clifton Forge Antiques Mall, have been joined by new ventures, such as the C&O Railway Heritage Center, Riders Up! Outfitters, Jack Mason's Tavern, Red Lantern Inn, the Willow Tree, Heirlooms Café, the Old Forge Coffee Shop, the Red Caboose, the Masonic Theater Restoration Foundation, and the Clifton Forge School of the Arts, to bring new life and energy to the community. Most important, Clifton Forge has never lost the essential element that has always been a hallmark of the community—it is a great place to live, filled with friendly people with a deep love for the place and a vibrant community spirit.

Thanks go to Horton Beirne and the *Virginian Review* for historical reference information.

One

FROM VILLAGE TO CITY

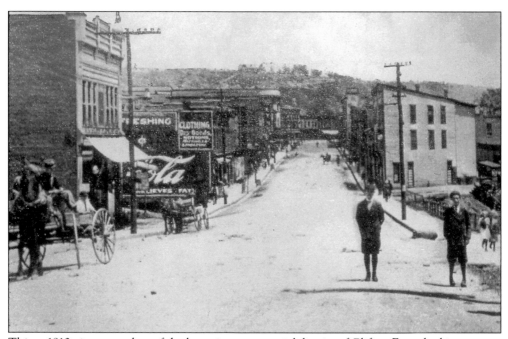

This c. 1910 view was taken of the booming commercial district of Clifton Forge looking east on Ridgeway Street. The streets are still dirt, but there are many large commercial buildings, including the First National Bank. At left is the 1898 W.W. Pendleton Building, which is the home of the C&O Historical Society today. The building on the right is where E.F. Scott, a successful black businessman, ran a hotel, barbershop, produce stand, and restaurant. (COHS.)

Andrew and Jean Smith Williamson came to the United States from Scotland in 1837. Jean's brother Henry Smith lived in this area, and Andrew and Jean settled here to be near her brother. Henry had no children, but Andrew and Jean were parents of seven children. The parents and their children were leaders, and the settlement became known as Williamson from 1850 until 1882. (HB.)

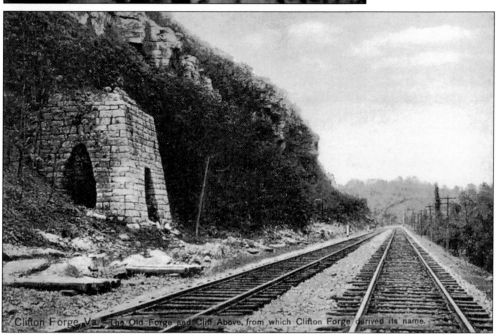

Clifton Forge, Va. The Old Forge and Cliff Above, from which Clifton Forge derived its name.

As early as 1822, a forge producing iron operated in the gap area between Iron Gate and Clifton Forge. This stone structure is a remainder of that era. It was owned by William Alexander, who named the forge Clifton for his family home. This name became a popular one used to refer to the area. In 1884, the town officially changed its name from Williamson to Clifton Forge. (HB.)

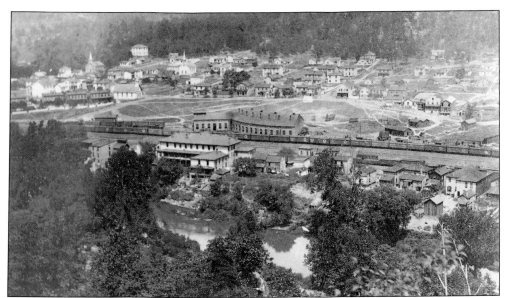

This is the earliest known photograph of Clifton Forge, and it shows the town in 1884, which was shortly after it was incorporated. Many landmarks can be seen, including three early churches and the McCurdy House, which served as a hotel and train station. The C&O shops, roundhouse, and freight depot are also seen. These facilities are located in what is now Smith Creek yard. (COHS.)

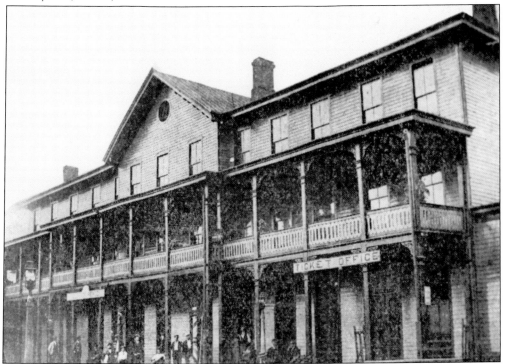

The McCurdy House and station was opened in 1882 by the McCurdy sisters of Covington. The McCurdy House was located on Jackson Street on the river side of the railroad tracks and was a popular stopover for many years for travelers. (HB.)

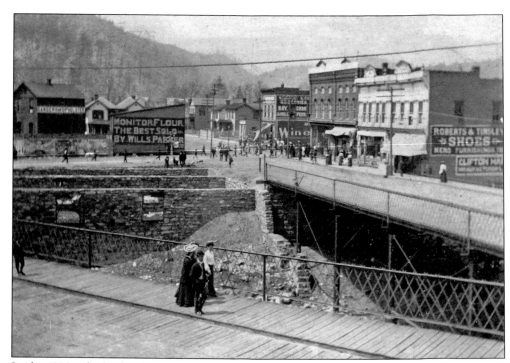

In the 1890s, the bridge that spans Smith Creek in the center of Clifton Forge on Main Street and Ridgeway Street was wooden, and the sidewalks were boards. In this photograph, one can see the foundation of what would later become the First National Bank and the Boxley Building. The Masonic Theater had not been built. (HB.)

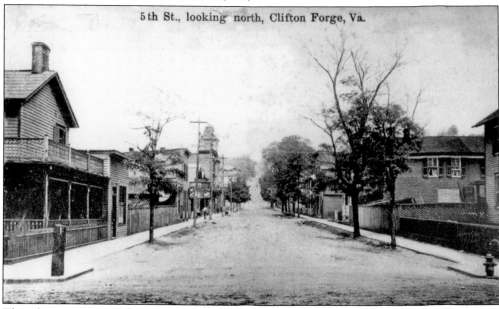

This photograph was taken around 1900 looking north on what is now Jefferson Avenue. In 1900, it was called Fifth Street. The house on the left is believed to be the first Eagles Home, and farther up the street on the left is the steeple of the Clifton Forge Presbyterian Church. On the right is G.W. Seasholes's undertaker and embalmer business. (HB.)

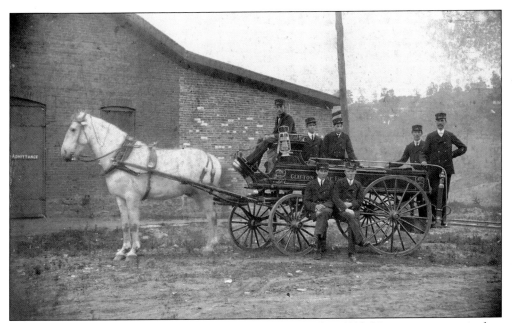

The Clifton Forge Volunteer Fire Department was organized in 1892. Here, one can see its first group of firemen, their truck, and their faithful horse, George. They look well prepared to fight a fire when it occurs. The fire department has served Clifton Forge and the surrounding area since the time of its organization with no break in service, and it continues today. (CFFD.)

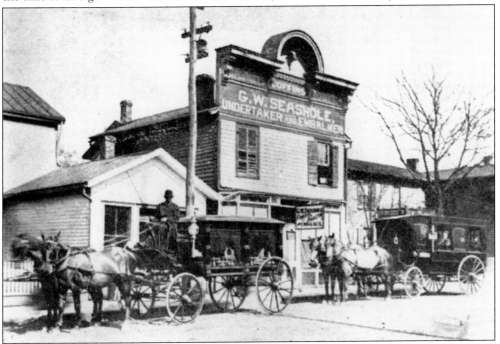

In the early 1900s, G.W. Seasholes, an undertaker and embalmer, had a business establishment at 314 Jefferson Avenue. It should be noted that the business also sold coffins. Funeral coaches are seen parked in front of his business. This location later became George H. Vermilya's Funeral Home and, later, a bus station. It is now the Red Lantern Inn, a guesthouse. (HB.)

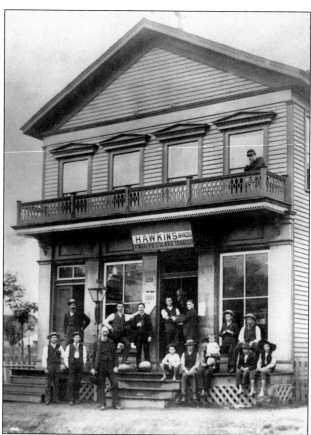

The Hawkins Brothers Store opened in 1886 on East Main Street. This building was one of the earliest commercial buildings in Clifton Forge and is still standing today. It housed the Virginia Coal and Supply Store, owned and operated by Jack Kimberlin, for many years. It is now J.J.'s Landscaping. (HB.)

Slaughter Pen Hollow defined the eastern end of the city in the early 1900s. This photograph shows citizens who continued to engage in farming at that time while living in the city. Today, the town's sewage treatment plant is located here. (HB.)

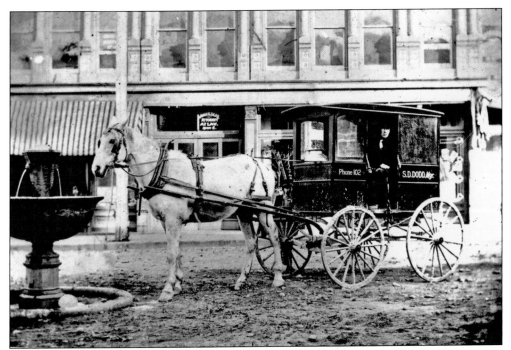

An iron fountain for horses to stop and have a drink of water was located at the juncture of Main Street and Ridgeway Street in 1900. Emmett Gilbert Sr. is the driver of the delivery wagon for S.D. Dodd's Dairy, located on the C&O farm. (Courtesy of Anna Mae Gilbert.)

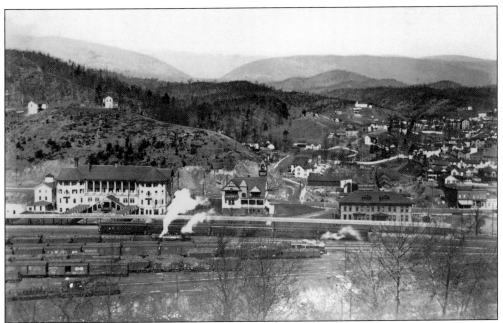

This panoramic view shows the Gladys Inn, the YMCA, and the C&O Office Building as they appeared in 1906. In the background, the scarcity of trees on Alleghany Street hill is thought by many historians to be due to the fact that most people heated their homes with wood stoves and the people simply cut down the trees for firewood. (HB.)

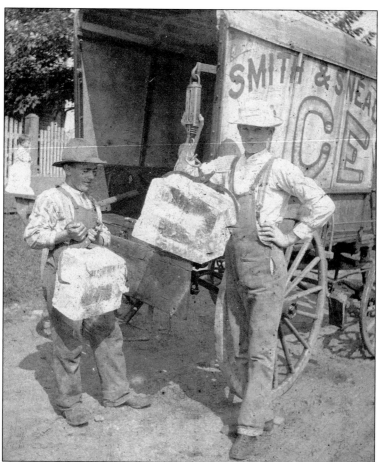

When E.A. Snead came to Clifton Forge in the 1890s, one of his first business ventures was partnering with D.E. Smith to form an ice company, which was called Smith & Snead Ice. Here, one can see Alfred M. "Shorty" Goodwin, on the left, and a helper delivering ice to a customer. (Courtesy of George "Chip" Snead.)

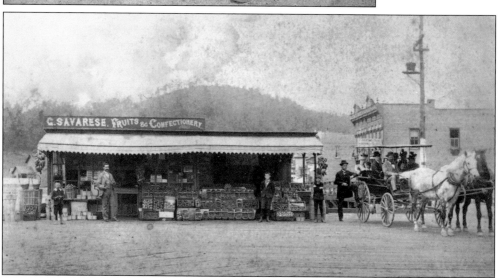

C. Savarese of Fruits and Confectionery enjoys a busy day. This business was located on the corner of Main Street and Ridgeway Street in 1885. Here, one can see the Moody Building to the right, and in the background is the hill commonly referred to as Alleghany Street hill. (HB.)

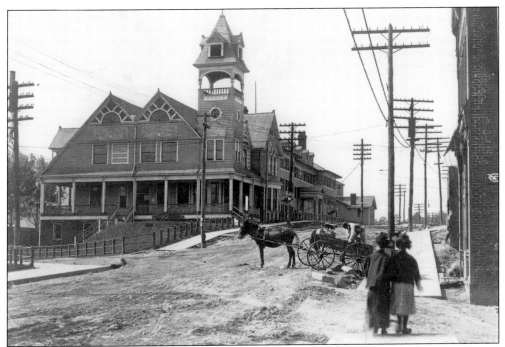

Taken around 1900, this image of the town reveals the fact that streets were not paved and travel was done on foot or by horse and buggy. The structurally beautiful Railroad YMCA Building is in the background and was, no doubt, the center of much activity in this era. (COHS.)

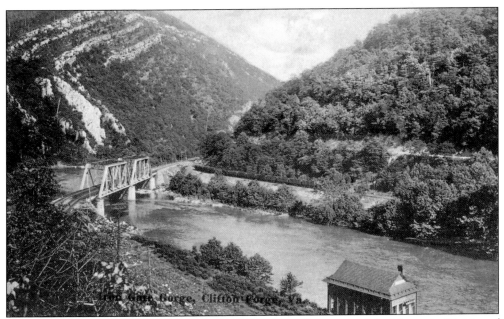

JD Cabin was located near the juncture of the James River Division and the Mountain Division of the C&O Railway. Across the river can be seen the remnant of the old Richmond & Alleghany Railroad line. This image also shows the breathtaking Iron Gate gorge. (COHS.)

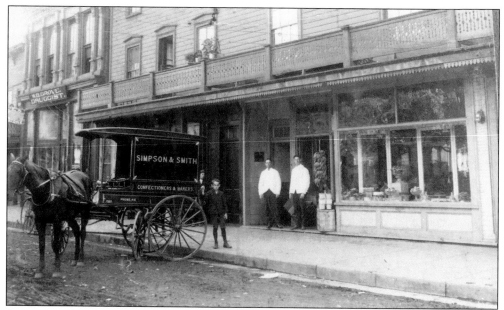

Simpson and David E. Smith ran a confectioners' and bakers' business around the turn of the century. Employees distributed their goods to customers with this delivery wagon, and here, they are making a delivery to a local grocery store. (Courtesy of Mike Glover.)

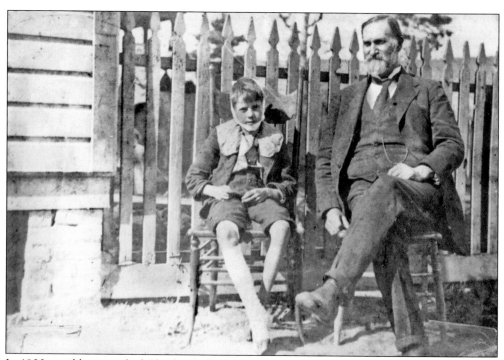

In 1900, a wildcat attacked Charles Gallagher. He is shown here after his partial recovery, with his attending physician, Dr. J.F. Hughes, the first physician to settle in Clifton Forge. (HB.)

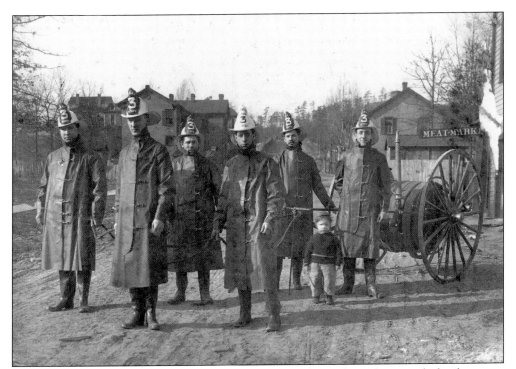

The volunteers with the Clifton Forge Fire Department have always been ready for their next challenge. The department was formed in 1892. Here, around 1900, one finds them in full gear with hand-drawn equipment. (CFFD.)

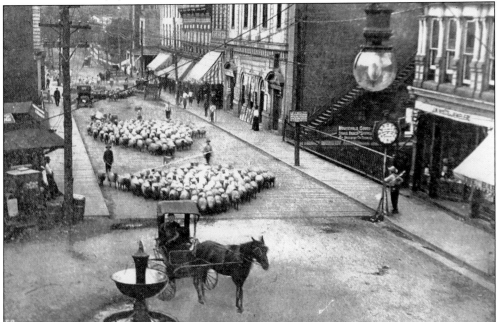

In this c. 1910 image, one can see flocks of sheep moving eastward on Main Street, most likely to the freight station for shipment. A horse with its buggy is seen at the fountain at the intersection of Main and Ridgeway Streets. (HB.)

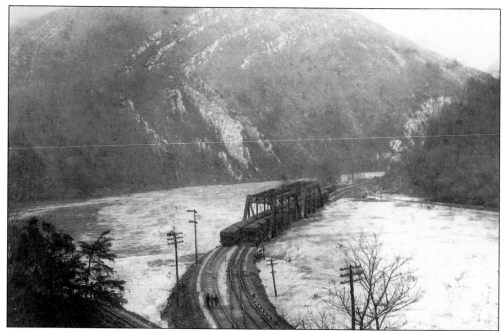

The flood of 1913 posed a danger to the bridge of the Chesapeake & Ohio Railroad crossing the Jackson River at the eastern end of Clifton Forge. The threat was so great that the railroad placed cars loaded with coal on the bridge to stabilize it against the flood. The flood washed away the original signal tower. The beautiful Iron Gate Gorge can clearly be seen in the background. (HB.)

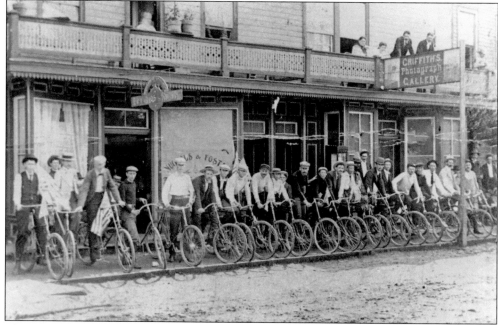

This is a gathering of a local bicycle club outside of Griffith Photography Studios on Main Street. Based on the style of the cycles, this image must be from some time after the turn of the century. Bicycling was very popular at this time and considered very high-tech. Communities established clubs with many enthusiastic members. (CFPL.)

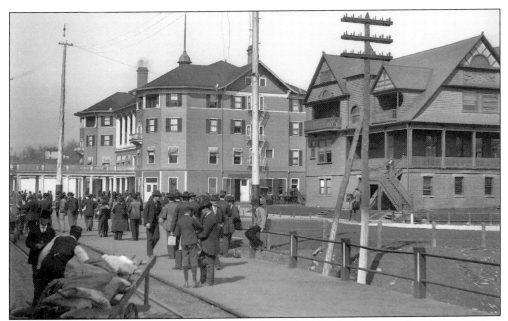

About 1900, most who traveled in and out of Clifton Forge rode the train. For those arriving, lodging, including delicious meals, was available at the Gladys Inn. In this photograph, one can see an unusually large crowd boarding and disembarking. The beautiful Gladys Inn and depot is on the left, and the YMCA is on the right. Note the electric arc lights on poles to illuminate the platform and the lack of the canopy. (COHS.)

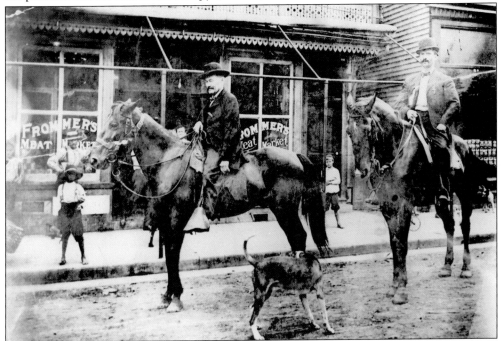

This image from the early 1900s shows two riders on horseback pausing in front of Frommer's Grocery before they continue. They have attracted the local children, who are watching with curiosity. (HB.)

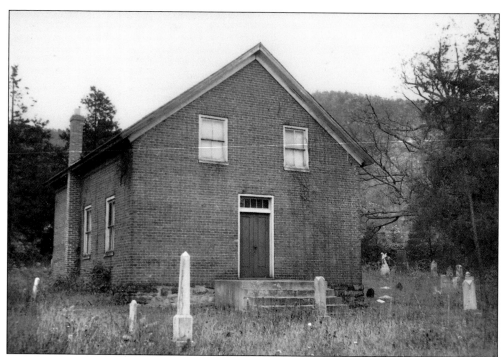

Oakland Grove Presbyterian Church is located on former Route 60 just west of Selma. It was built between 1845 and 1847 and is the oldest known church in this area. It served as a Confederate hospital during the Civil War. Col. William L. "Mudwall" Jackson made the area near the church his headquarters when he was defending the area. There are 12 Confederate soldiers buried in the cemetery near the church. (HB.)

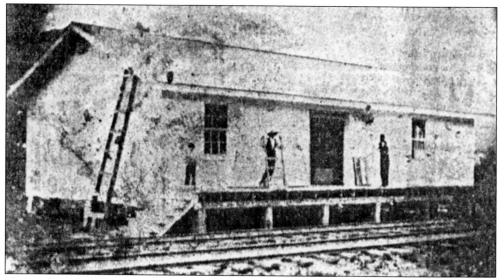

Here is the only known photograph of Jackson's River Station of the Virginia Central Railroad, established in 1857 and located adjacent to Oakland Church. The photograph was taken from an old tintype photograph that was first published in the *Covington Virginian* newspaper in 1957. The station was a simple structure typical of the time. It was the end of the line until 1869, when the road began building west again. It was reportedly burned by Union troops. (COHS.)

Two

THE DOWNTOWN

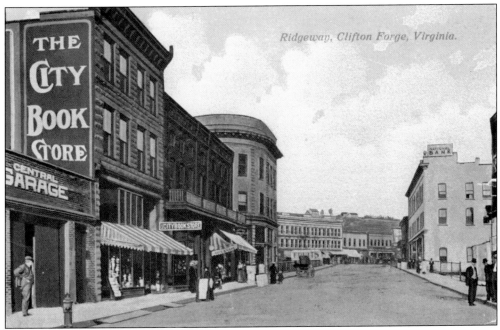

Clifton Forge grew quickly, and each year saw new and larger buildings. It had an impressive number of large and architecturally significant structures, as well as many shops and services not seen in towns of its size. This c. 1920 postcard image shows the Boxley Building on the left, the Alleghany Building on the right, and many storefronts, including the Central Garage and the City Bookstore. (COHS.)

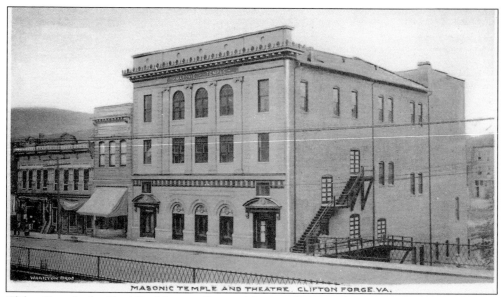

Clifton Forge Lodge No. 166 of Ancient Free and Accepted Masons (AF&AM) built this combined opera house and lodge in 1905. The Masons held their meetings in the lodge on the third floor from 1906 to 1921. It was bought by Sol Sachs in 1920. Beginning in 1906, the theater hosted plays and vaudeville shows. Well-known celebrities who made appearances there included Lash LaRue, Roy Rogers and Trigger, Hopalong Cassidy, and Gene Autry. (CFPL.)

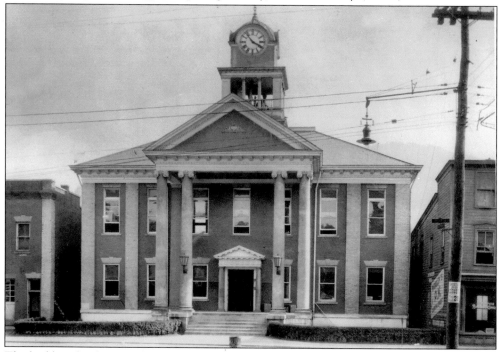

The building for the town hall and courthouse was erected in 1910–1911 on Main Street at the location where Jefferson Avenue intersects with Main Street. Of interest in this photograph are the style of streetlights, the wooden buildings that lined the street on the south side of Main Street, and the beautiful clock tower with observation cupola. (HB.)

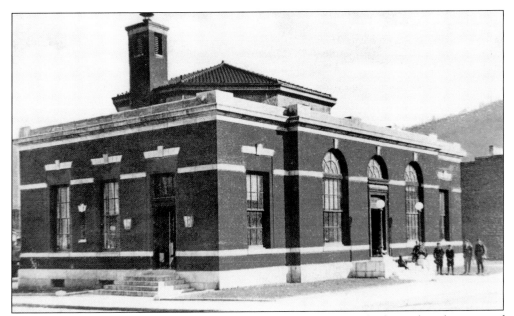

The Clifton Forge Post Office, a Beaux-Arts design by James Knox Taylor located on the corner of Church and Commercials Streets, is the town's most sophisticated building. It was completed in 1910. Surmounted by an octagonal rotunda with tile roof, it features high round arched windows that flood the interior with light. The interior features beautiful marble floors and a vaulted plaster ceiling. (CFPL.)

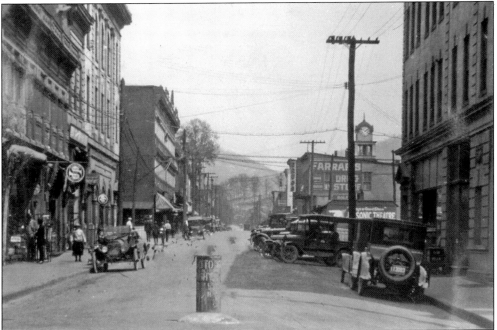

Here is Main Street in Clifton Forge in the early 1920s looking east. It is interesting to note that some of the automobiles are parked parallel and some are backed in at an angle. There is an obstacle in the center of the road, and it is puzzling what purpose it serves. It may have been a device to control traffic. (CFPL.)

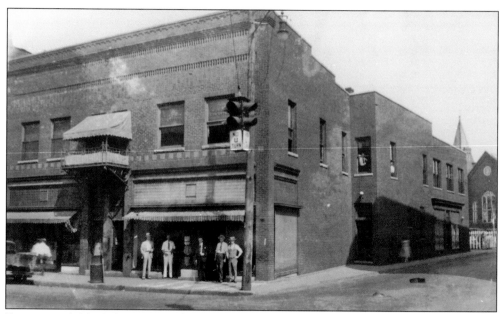

Zimmerman's Men's Store opened in 1903 and was located on the corner of Ridgeway Street and Commercial Avenue. It offered high-quality men's clothes and satisfied a good selection of work clothes needed for the several thousand men who were employed by the railroad. W.W. Zimmerman and W.T. Wade owned the business for many years before it was sold to Wiley Mitchell and Robert Williams. (CS.)

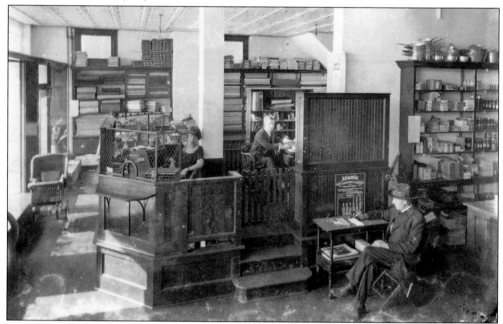

This is the interior of the People's Store, located on Ridgeway Street at Race Street and built in 1922. It later became Fitzgerald's, the railroad employee commissary or company store. Employees of the railroad came here for items they needed for both work and home. At one time, a bowling alley was upstairs. Later, it became a hardware and paint store. Today, it is the home of Jack Mason's Tavern. (CS.)

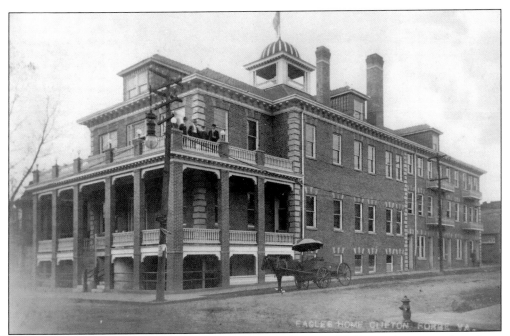

The Eagles Home was located on the corner of Main Street and Jefferson Avenue and was later remodeled into the Hotel Jefferson in 1927. The Eagles Society was a fraternal organization and it is widely assumed that it built such a handsome home for members who did not have an established home elsewhere. (HB.)

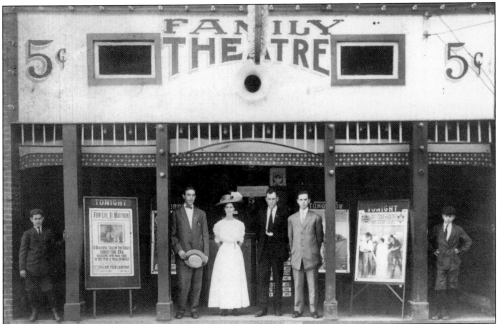

The Family Theatre was located on Ridgeway Street. It was owned and operated by Otto Fisher, who is pictured on the left, learning against the post. His wife, Effie Fisher, played the piano during the era of silent movies. The Family Theatre later became the Ridge Theater, and today, the building is used as a workshop for an antique store. (HB.)

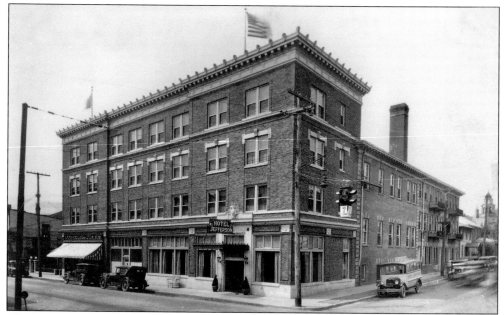

The Eagles Home was rebuilt into the Hotel Jefferson in 1927 on the corner of Main Street and Jefferson Avenue. There was a need for a "safe, fireproof" hotel. This was an elegant and modern hotel at the time it was opened to the public, and its facilities were in demand. It was torn down in 1976, when the Mountain National Bank built a new bank in that location. (CS.)

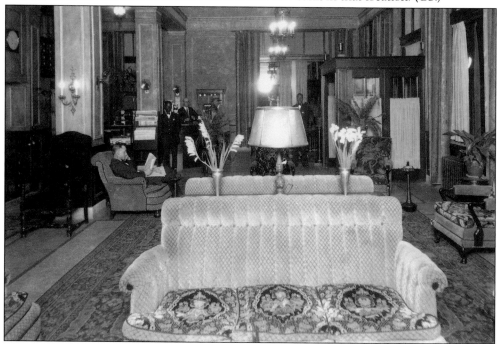

This photograph shows the beautiful lobby of the Hotel Jefferson, and off of the lobby was an equally lovely dining room. The coffee shop was located next door. Many local organizations, such as the Kiwanis Club, the Lions Club, and the Last Man's Club, met here on a regular basis for lunch and dinner meetings. (CS.)

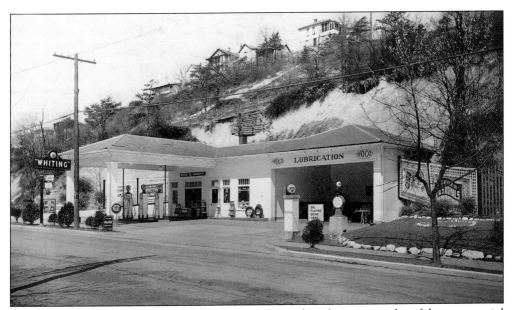

Here is the Whiting Oil Company service station, located on the western edge of the commercial district on Ridgeway Street, in the 1930s. The Whiting Oil Company was an important local business that distributed oil and gasoline regionally. Its corporate office was located above Zimmerman's Men's Store. The company is still in business today as Whiting-Jamison, and the structure is still there, waiting for someone to restore it. (CS.)

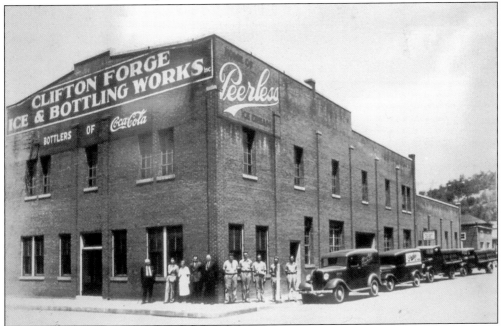

Ambrose C. Ford and C.P. Nair established the Clifton Forge Bottling Works in 1900, acquiring the Coca-Cola franchise in 1902. The ice plant was added in 1906, the ice cream buiness with Peerless Creamery in 1909, and the retail milk business in the early 1930s. Under the leadership of C.P. Nair Jr. as president and manager, W. Kent Ford as treasurer, and H.R. Larrick as secretary, the company grew. In 1972 the business was sold to Wometco Enterprises, Inc. (CKH.)

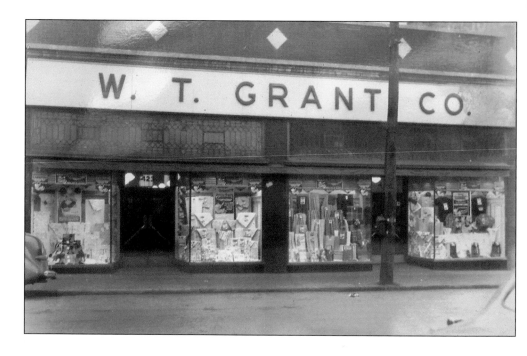

From the 1920s until the 1970s, five-and-dime stores were quite popular. A shopper could find household items, kitchen utensils, and cosmetics at reasonable prices. At that time, retail stores were much more specialized. Grocery stores carried only food items, clothing stores stocked men's or women's clothing, and furniture stores offered larger home furnishings. So the five-and-dime stores were the answer for many needs. Clifton Forge had two such stores associated with national chains. The F.W. Woolworth Company store was located in part of the Hotel Jefferson building on Main Street, and the W.T. Grant store was located on Ridgeway Street. (Both, CS.)

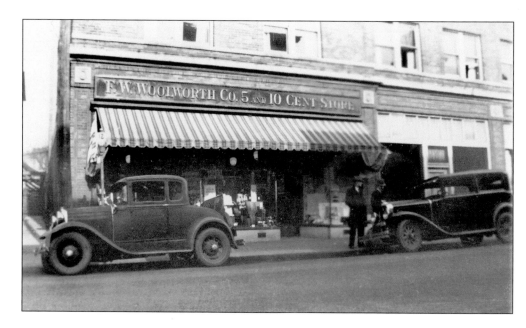

A man of many talents, Frank Wheeler was Clifton Forge mayor from 1928 to 1942; local fire chief from 1916 to 1967; State Firemen's Association president, from 1932 to 1939; and judge of the Clifton Forge Police Court. During World War II, he was appointed by Gov. James Price to organize emergency fire protection throughout Virginia. Born in 1881 in Hillsboro, West Virginia, Frank "Shag" Wheeler was very influential in the development of Clifton Forge. (CKH.)

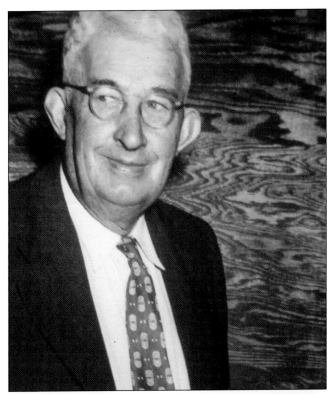

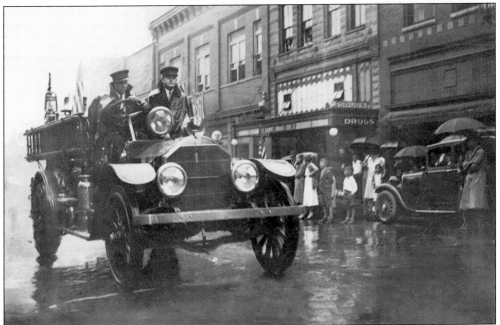

Few people like to have their parade rained on, and unfortunately, this late 1930s parade is being rained on. Nevertheless, this handsome fire truck is attracting a following of spectators. The parade is heading east on Ridgeway Street, with Clift Drug Company and Zimmerman's Men's Store in the background. (Courtesy of Kelly Slusser.)

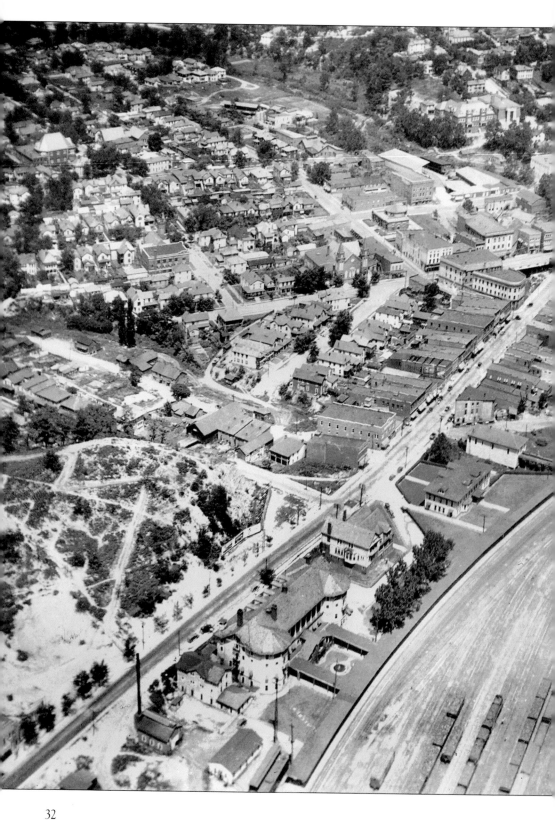

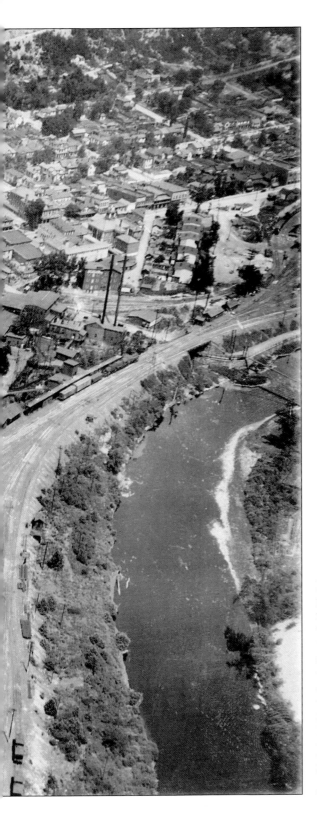

Here is an amazing aerial photograph of Clifton Forge from 1923. Ridgeway Street runs west to east diagonally. Many important structures are clearly seen in the photograph, including the Gladys Inn, YMCA, division office, Railway Express, and the yard office; along Ridgeway are Smith McKinney Hardware, the People's Store, the Boxley Building, the Masonic Theater, the town hall, and the First National Bank. This likely was taken from an open-cockpit biplane! (COHS.)

Edwin A. "Deacon" Snead came to Clifton Forge in 1892 and immediately became involved with activities in the town. In 1907, he was president of city council and established the Snead Furniture Company. He was known to always wear a red necktie. He represented this area in the Virginia House of Delegates in Richmond for many years. (Courtesy of George "Chip" Snead.)

The Snead Building, located on the corner of Main Street and Commercial Avenue, was built in 1890 by J.C. Carpenter Sr. Snead's Furniture Company occupied it from 1907 until 1987. Originally, other merchants, including a bakery, used half of the building. (Courtesy of George "Chip" Snead.)

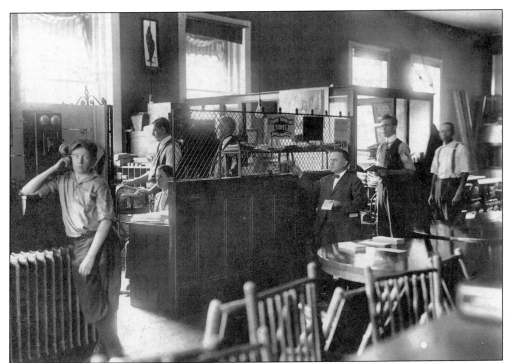

Inside Snead's Furniture Store in 1915, employees gather around to discuss the day's business. From left to right are George C. Snead, talking on the telephone; J.B. Goodwin, sitting at the desk; Charles Proffitt, standing at the desk; owner E.A. Snead, standing in the office; A.M. Goodwin Jr., standing at office window; Dode Whiting, standing with open book; and Bill Hatcher. Bill Hatcher was waiting for the next delivery to be made. (Courtesy of George "Chip" Snead.)

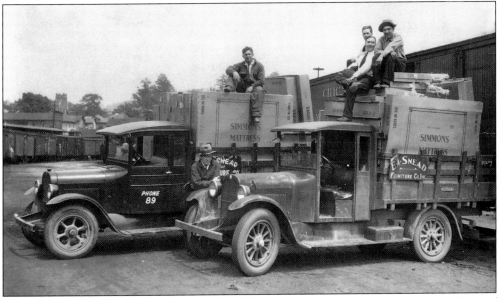

Snead's Furniture Company's trucks are lined up at the C&O freight depot to pick up a delivery of mattresses, among other things. The year was 1927. Of interest is the two-digit telephone number on the side of the truck. (COHS.)

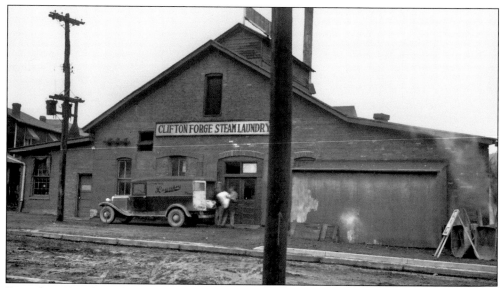

From the 1920s through the 1960s, the Clifton Forge Steam Laundry operated on the corner of Commercial Avenue and Pine Street. Lewis Stratton was the owner and operator much of this time. The laundry satisfied the needs of private households, businesses, and professional offices, as well as providing laundry service to the railroad for a period. (CS.)

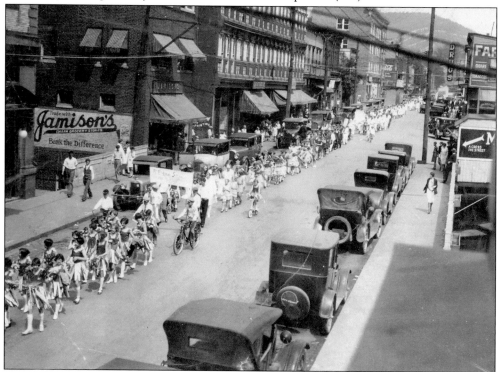

A parade is moving from east to west on Main Street in the 1920s. The Masonic Theater and the Lavin Building are on the left, and farther to the east on the left is the Hotel Jefferson. On the right is Farrar's Drugstore. By this time, automobiles were a more popular way to get around, as evidenced by the number parked on the street for the parade. (HB.)

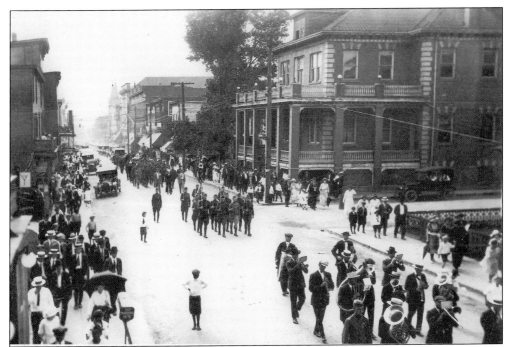

During World War I, brothers Roland A. and Rayburn Williams were killed in action. They were given a funeral with full military honors. This image shows the funeral cortege moving east on Main Street, passing the Eagles Home on its way to Crown Hill Cemetery. Here, one can see the band and the military battalion, with Anderson Clarkson marching along side. (Courtesy of Mike Glover.)

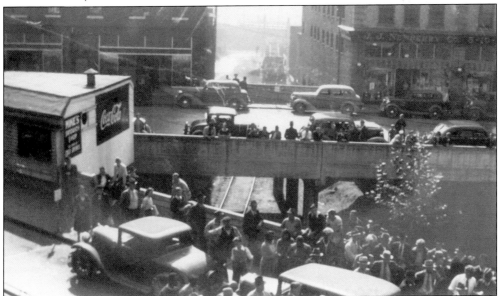

The bridges on Main and Ridgeway Streets are seen in this photograph of the 1930s–1940s. In this image, the spur railroad track, which runs under the bridges and up Commercial Street, can clearly be seen. On the left is the hot dog stand that occupied the tip of the triangle for many years. Today, the Sona Bank Building occupies this spot, supported by piers. (CS.)

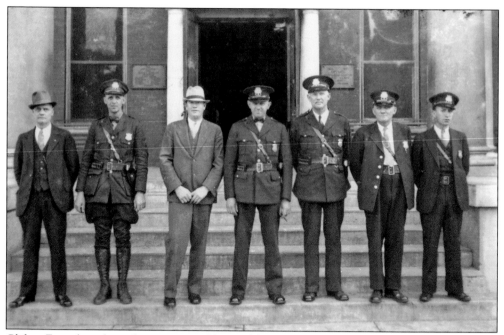

Clifton Forge has always been protected by an able police force. Here, one can see the 1930s-era force standing in front of city hall. The chief is John W. Huffman Sr. (third from left, dressed in street clothes), and the others are unidentified. (CS.)

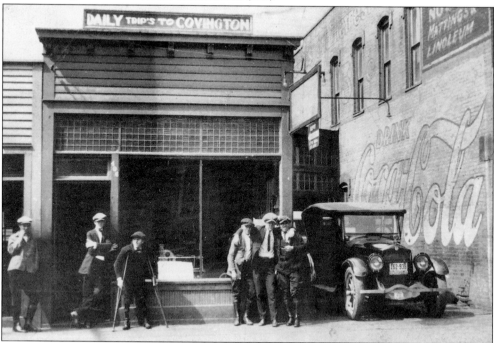

Beginning as early as 1915 and continuing into the 1950s, the Otto family operated a store and a transportation company. The Ottos had three sons, Joe, Morris, and Julius "Pip" Otto, who helped manage the business. They offered regional bus service to Covington, Lexington, and Roanoke. They also operated a taxi service. The business front was on Ridgeway Street. (CKH.)

Located on the corner of Main Street and D Street, Harry Shepherd Sr. operated an Oldsmobile automobile dealership in the 1930s. He also sold Goodyear tires, and in this photograph, the business is being visited by the Goodyear Tire Company, displaying the "world's largest tire." The tire was so large it reached to the second story of the building. (Courtesy of Brian Shepherd.)

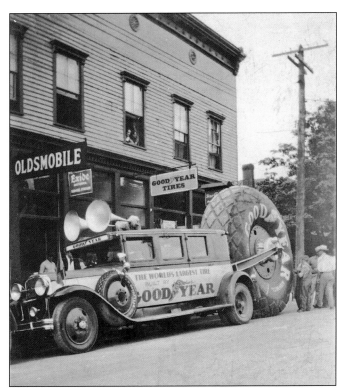

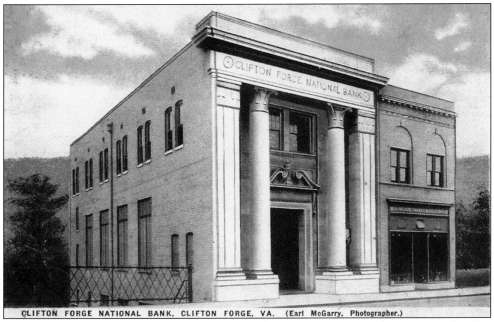

CLIFTON FORGE NATIONAL BANK, CLIFTON FORGE, VA. (Earl McGarry, Photographer.)

The Clifton Forge National Bank, located on Ridgeway Street, operated in 1920s and 1930s. It suffered the misfortune of many banks at that time and, in 1933, during the height of the Depression, failed its depositors. The directors issued participation certificates, and attempts were made to satisfy its depositors. It reopened on June 4, 1934, as Mountain National Bank and continued successfully following the crisis. (CFPL.)

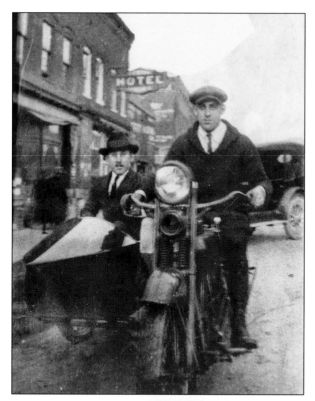

The Otto family operated transportation services in Clifton Forge in the early 1900s. Here, Morris Otto is giving Charles P. Deaton a ride in his new Harley Davidson motorcycle with a sidecar in 1934. They are parked at Otto's taxi stand. It is interesting to notice there was a hotel in this area on the north side of Ridgeway Street then. (CKH.)

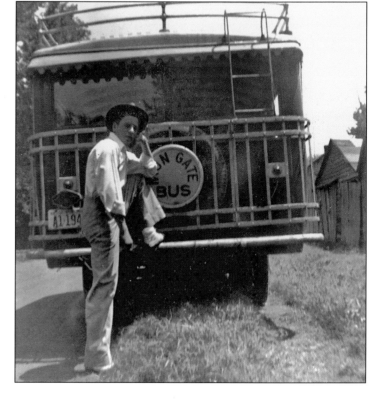

During the 1930s and 1940s, the Iron Gate bus was quite active, accommodating the citizens of both Iron Gate and Clifton Forge. Several trips a day brought citizens to shop, work, and visit between the two locations. Jack Unroe owned the bus, and it was driven by Emmett H. Tyree. (Courtesy of Oscar Hunt.)

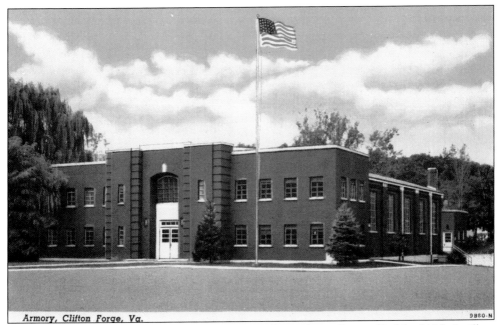

Armory, Clifton Forge, Va.

The armory, built for Clifton Forge's Virginia National Guard unit, Battery E of the 246th Artillery of the 29th Infantry Division, was completed in 1941 with funds from the WPA and the state and city governments. It was also used by Clifton Forge High School and the Lions Club for youth nights and other community activities. It is managed by the Clifton Forge Armory Committee, which is working to restore this civic asset. (CKH.)

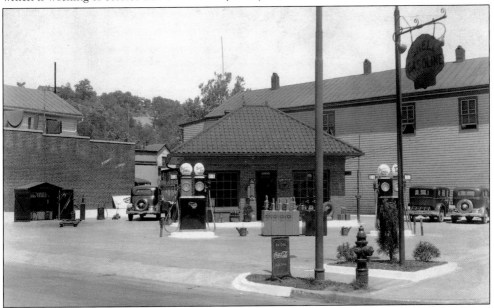

This is the Shell service station located at the corner of Main and Jefferson Streets, just across the street from Clifton Forge Town Hall. It is a classic 1920s-era fueling station, which was later replaced by a much larger building that was occupied for many years by Mike Simmons's ANC auto repair service (Aaron Nicki Chris, named after his children). It is being renovated as a branch office of James River Realty. (CS.)

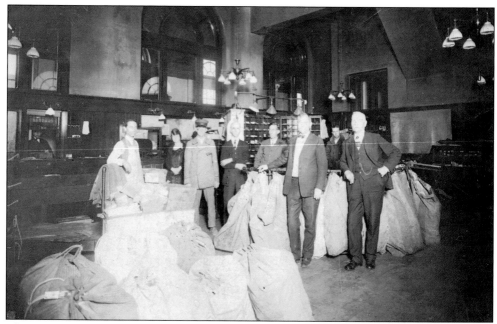

This image gives a look inside the Clifton Forge Post Office in the 1930s and the way the mail was handled at that time. The two men on the right are Jess N. Cahoon, assistant postmaster, and W.D. Bowles, postmaster. The woman is Nellie Leitch. Others are not identified. (Courtesy of Nancy Cahoon Gilbert.)

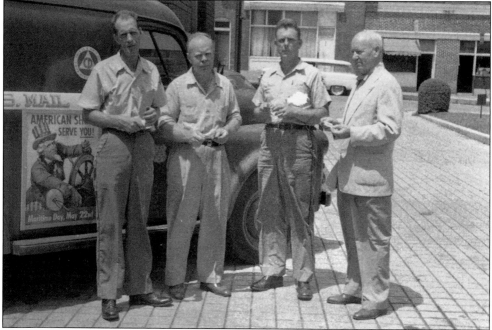

US Post Office workers pictured are, from left to right, John Kling, Milton Cahoon, John Corstaphney, and Jess Cahoon, Clifton Forge postmaster. These three gentlemen served as mail carriers for a number of years, and Jess Cahoon had given them their service pins. John Corstaphney was later appointed postmaster when Cahoon retired. (Courtesy of Diana Kling-Smith.)

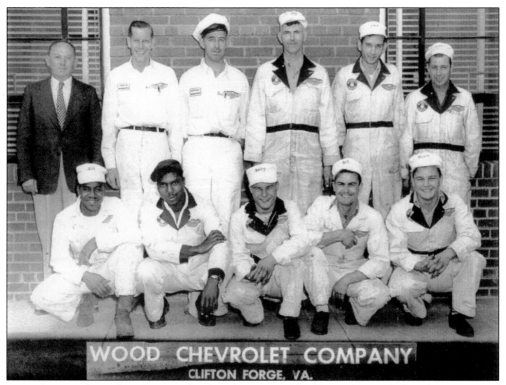

In 1945–1946, the Robert E. Lee School in the west end had been dismantled, and Henry Wood purchased that land and opened a new Chevrolet garage on that site. Shown around 1948 are, from left to right, (kneeling) B. Brown, H. Lee, B. Higgins, E. Higgins, and G. Higgins; (standing) R. Weber, B. Slusser, P. Hoke, H. Dill, B. Craft, and P. Wolfe. (Courtesy of Kelly Slusser.)

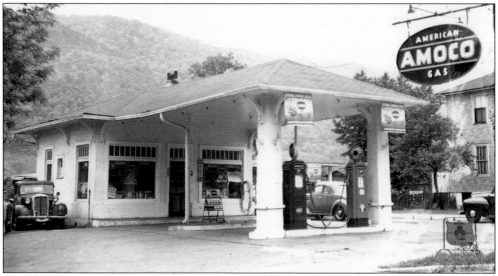

This Amoco station operated on the corner of Main Street and D Street on the east end of town. Based on the 1923 aerial photograph, it may have been the first service station in Clifton Forge. This photograph was taken in the 1930s. Main Street in Clifton Forge was also the busy east-to-west thoroughfare of US 60. Sadly, this building was torn down and replaced with a car wash. (CS.)

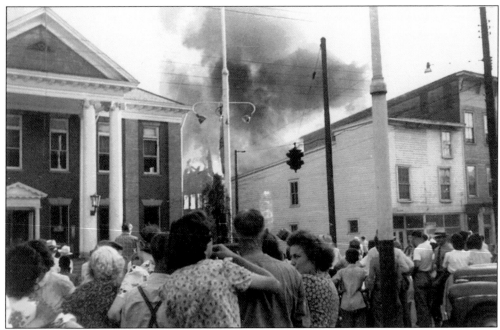

Here is the fire that started at city hall. On July 29, 1944, citizens gathered to watch the fire, which ravaged a block of Main Street and city hall. It began around 6:00 p.m. in the milling and feed company, shown here in flames, which was located on Jackson Street behind the shops on Main Street. (Photograph by Jean H. Manner, courtesy of CFPL.)

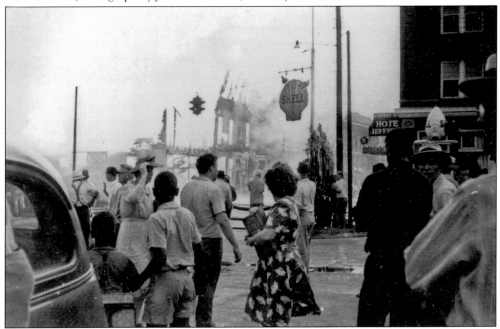

The fire moved rapidly down Main Street, destroying the buildings in the 500 block, which included a grocery store, a barbershop, and other businesses. There were apartments on the second and third floors, which were ravaged. All belongings were lost as the fire accelerated from one building to another. (Photograph by Jean H. Manner, courtesy of CFPL.)

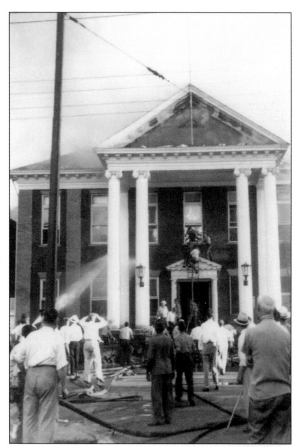

Shown at right, volunteers began removing records from the city hall as the fire progressed on Main Street. Records were carried from the offices of the clerk of court, the treasurer, the commissioner of revenues, and the police department. Efforts to hose city hall were futile. The fire engulfed the building, causing the clock tower to fall. Firemen can be seen climbing from the second-floor circuit courtroom after the clock tower had crashed down as flames were engulfing the room behind them. The heat was so intense that the hotel's facade across the street was scorched. No life was lost in the fire, but several firemen were injured. City hall damage was extensive. Temporary quarters were set up in the armory until the city hall was repaired. The clock was replaced in 1968. (Both photographs by Jean H. Manner, courtesy of CFPL.)

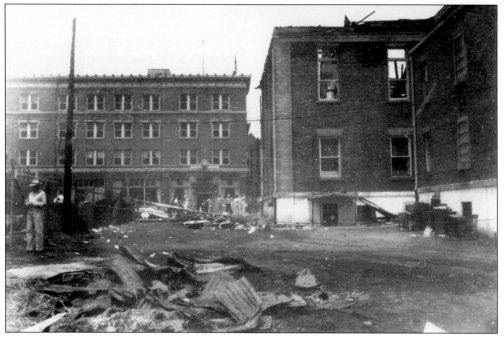

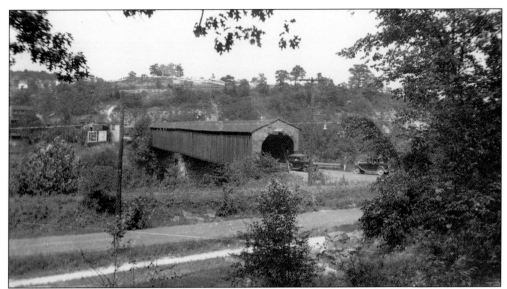

This covered bridge connected Verge Street to Main Street and crossed the Jackson River. It connected the citizens on the south side of the river to the growing city on the north of the river. It was also the crossing that connected to US 220 South to Iron Gate, Eagle Rock, and Roanoke. To reach it, one went down River Street, under the railroad tracks, and along a road beside the river. The updated 801-foot concrete bridge replaced it in 1937. (CS.)

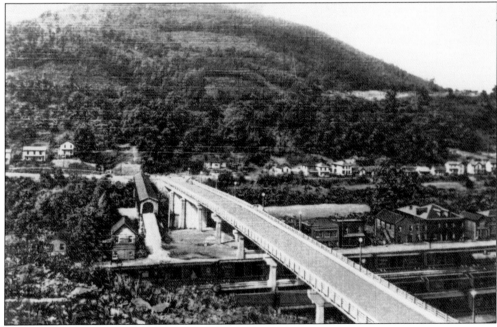

The long-awaited bridge across the railroad tracks and the Jackson River was complete at last, and this photograph shows the completed new bridge and the old covered bridge side by side. The new bridge was completed and dedicated on September 6, 1937. It connected Verge Street with Main Street directly. (CS.)

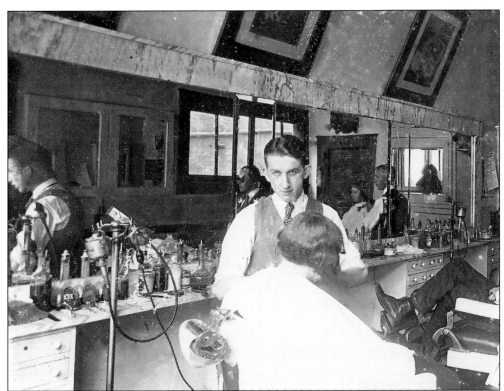

In the 1930s, this shop was owned and operated by Robert Layne, shown here cutting a lady's hair. Robert, his brother Gaston, and G.K. Crawford were the regular barbers. Their business was destroyed by the 1944 fire. Crawford later moved across the street and operated a shop in the Hotel Jefferson building. (CS.)

Henry Sampson's Lunch was originally located on Ridgeway Street. It operated later in the 500 block of Main Street. Sampson, shown here at the Ridgeway site, was a talented wood carver as well as a great cook. He often displayed his attractive carvings in the lunchroom window. (CS.)

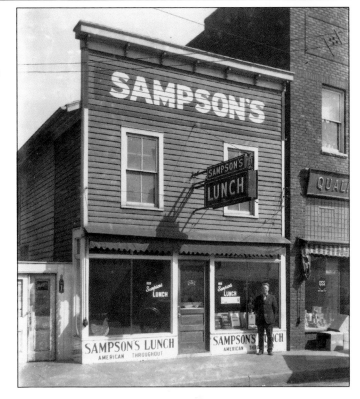

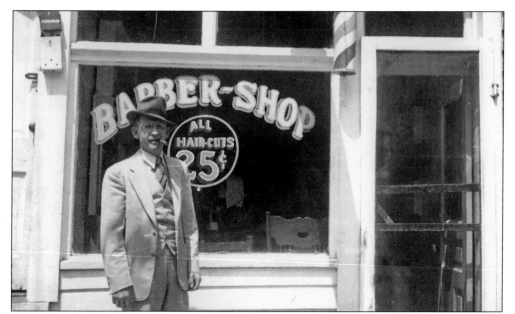

"Baldy" Curtis is in front of his barbershop ready to start the day's business. He operated his shop on Ridgeway Street from the 1930s until the 1950s. (CS.)

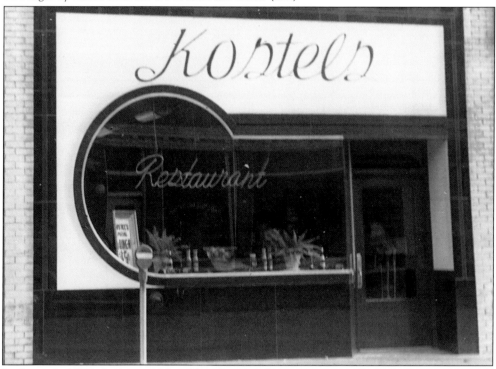

In the early 1930s, James and Mary Kostel operated a restaurant on lower Ridgeway Street. In 1937–1938, the Kostels moved into the space vacated by Fliess's Department Store. The building was renovated, and what was considered a very "modern" front was added. For many years, they operated a popular restaurant in this location. This space is now occupied by Victor's Restaurant, owned by Steve Greenblatt. (Courtesy of George Kostel.)

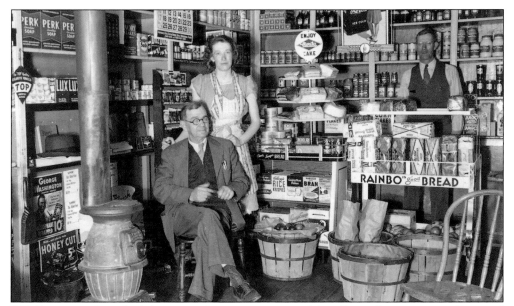

W.J. Enos, seated on the left, operated a grocery store on Main Street for many years. Enos and one of his employees are pictured here in the 1940s taking a short break. The full line of groceries he offered can be seen, including staple goods and fresh vegetables and fruit. (CS.)

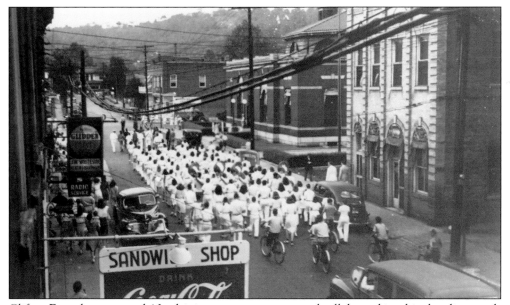

Clifton Forge loves a parade! In this image, one can see people all dressed in white heading north on Commercial Avenue in the late 1930s. The Sandwich Shop sign that can be seen in the left foreground was F.A. Dudley's, and on the right is Carpenter Building, which has housed many businesses and offices; next to it is the stately post office. (CS.)

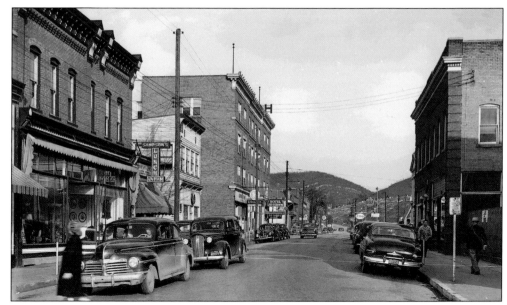

Looking east on Main Street in 1948, one can see many of the businesses that were thriving at that time. Shown are Smith-Rule Furniture, Sampson's Lunch, and the Hotel Jefferson on the left, along with the Alcohol Beverage Control store on the right. In the distance, one can see Mountain View Cemetery and Rainbow Rock. The photographer may have just turned around to take the picture to the west. Here, one can see J.J. Newberry Company and other businesses on the left and the Boxley Building on the right. (Both, HB.)

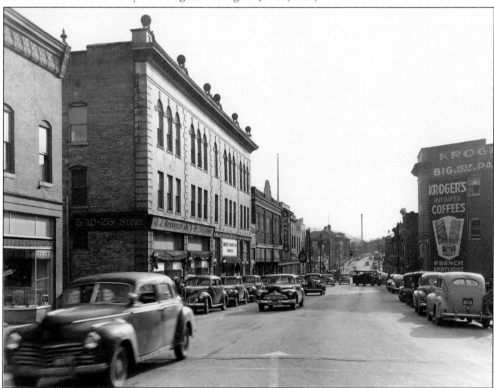

Three

THE RAILROAD

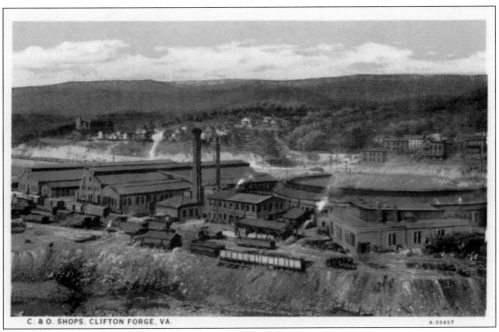

C. & O. SHOPS, CLIFTON FORGE, VA. A-55657

The development of Clifton Forge was shaped by the railroad, which first arrived in 1857. The land between the river and the town was completely filled with the railroad, yards, and shops. The shops, shown in this postcard around 1910, were the center of railroad activity. From right to left are the roundhouses, power plant, machine shop, and locomotive repair shops. Note the hospital in the background. (COHS.)

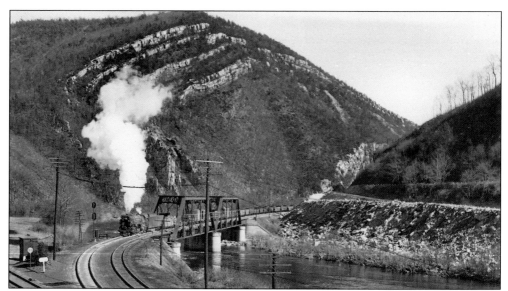

This view looks east toward the Iron Gate Gorge and Rainbow Rock. It is the eastern rail gateway to Clifton Forge and the intersection of the Mountain and the James River subdivisions. Crossing over the Jackson River Bridge, a freight train is headed into town. (COHS.)

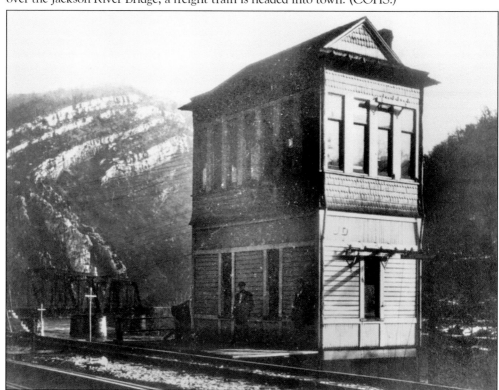

This signal tower was known as JD (James Division) Cabin and guarded the eastern approach to Clifton Forge and the intersection of the two rail lines. This tower was built some time during the 1890s, was lost in the flood of 1913, and was later rebuilt to a simpler design. A replica of this tower is located at the C&O Railway Heritage Center. (COHS.)

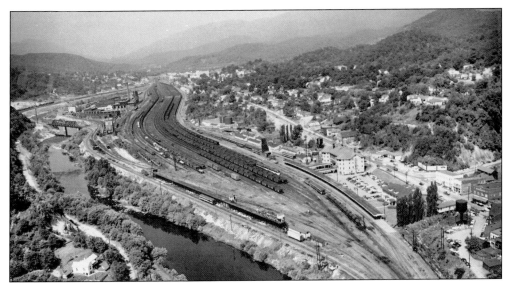

An aerial view of Clifton Forge looking west shows the building for the station, YMCA, and offices in the right foreground, and the coal classification yard and shops in the background. The icing platform is visible next to the river. It was used to re-ice shipments of meat and vegetables from the west and shipments of apples and fruits from Virginia's heartland headed west. (COHS.)

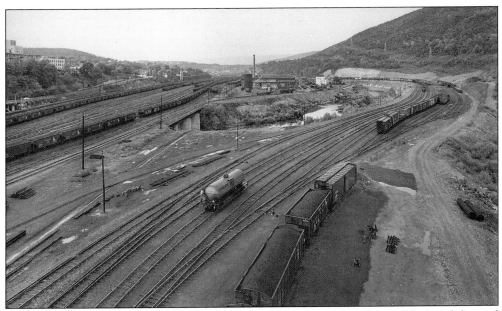

Here is the Selma Yard looking east toward the shops and Clifton Forge. This yard, located across the river in Selma, was for the classification of merchandise freight. The hump yard seen to the left in the photograph was for the classification of coal shipments headed for the docks at Newport News. (COHS.)

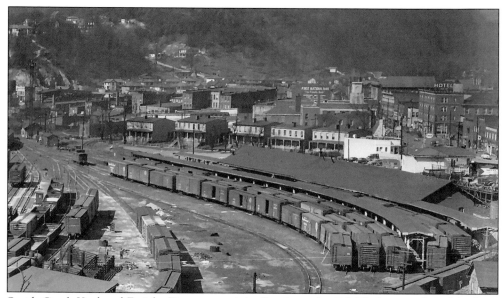

Smith Creek Yard and Freight Depot are originally where the C&O's shops and yard facilities were located. In 1889, those facilities were moved west and expanded. This area became the less-than-carload freight yard. The freight depot to the right is where shipments to Clifton Forge were delivered. The stockyard to the left was used for watering stock in transit. Note the old railroad tenement houses in the background. (COHS.)

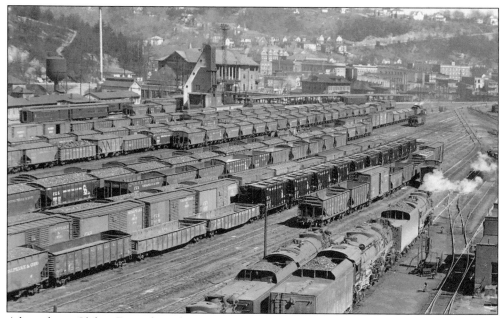

A busy day at Clifton Forge shows locomotives on the ready line in the foreground. In the middle are freight trains ready to head out. In the background are coal trains and passenger trains at the station. This level of activity was an everyday occurrence here and went on 24 hours a day, seven days a week. (COHS.)

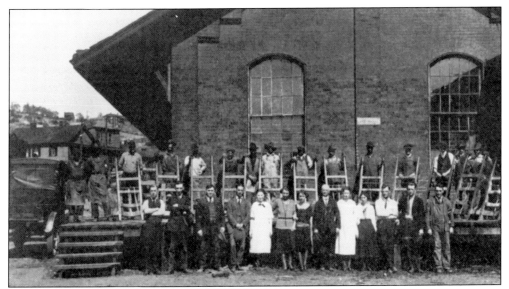

This early image of the Smith Creek Yard Freight Depot shows the workers at the depot lined up on the western platform around 1922. Note the laborers on the top with their hand trucks and the office staff below. This structure was originally built in 1895 and has been restored and is in use as the main exhibit hall of the C&O Railway Heritage Center. (COHS.)

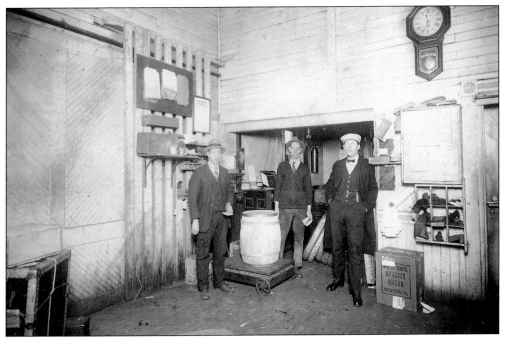

An interior view of the freight depot in the early 1900s shows a barrel of something being weighed. The man on the left is Robert Willis Woods (grandfather of Thomas "Tommy" Woods), who came to Clifton Forge from Richmond to be a master mechanic. The other two men are unidentified. (Courtesy of Marilyn Woods.)

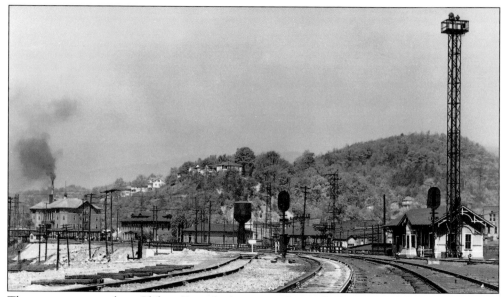

The eastern approach to Clifton Forge looking west shows the location of the 1891 passenger station, the Railway Express Agency office, the division office building, the Gladys Inn, and YMCA. The tracks in the foreground are the east- and westbound main lines; the track to the left is the switching lead to the yard. On the right is the original 1891 passenger station, later used as a yard office. (COHS.)

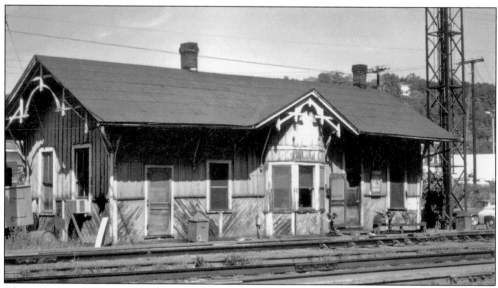

This structure, shown just prior to its razing in 1974, was originally Clifton Forge's passenger station, built in 1891 and supplanted by the construction of the Gladys Inn in 1897. It became the yard office for Smith Creek Yard. The C&O Railway Heritage Center has a replica of this structure. (COHS.)

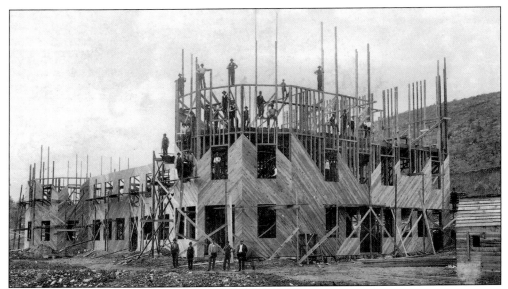

The Gladys Inn is under construction in 1896. The original Gladys Inn, named for the daughter of the president of the railroad, Melville E. Ingalls, was located on a bluff west of town. In 1897, it became the C&O Hospital, and a new hotel was needed. This combination hotel-station was built as its replacement and became the passenger station for Clifton Forge. (COHS.)

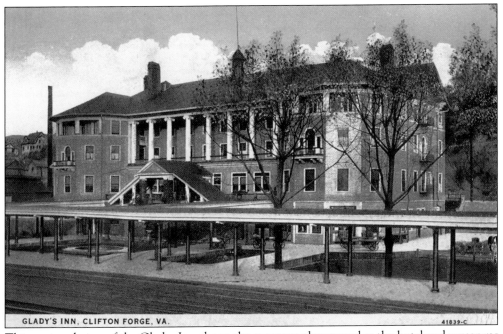

GLADY'S INN, CLIFTON FORGE, VA. 41839-C

This postcard view of the Gladys Inn shows the structure that served as the hotel and passenger station for Clifton Forge. In the lower right-hand section of the building was a restaurant. In later years, the restaurant became known as the Bull Pen and was well loved for its home-style cooking. Legend has it that a small crocodile lived in the fountain in its courtyard. (COHS.)

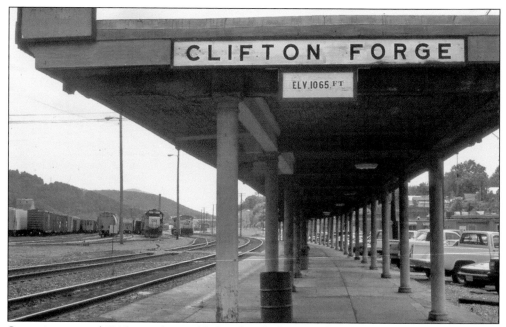

Some time around 1915, a roof was added to the platform. In this photograph, looking from east to west, one can see the hauntingly beautiful platform with not a single passenger waiting to leave or to arrive. An empty platform was a rare occurrence, but this platform said "welcome to Clifton Forge" to strangers and home folks returning as much as any other structure in town. (CKH.)

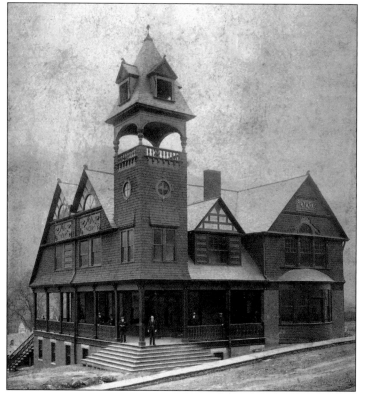

The original YMCA was built in 1896. This structure was one of the first YMCAs that were built to provide traveling railroad men a clean and upright place to stay. The C&O embraced this concept and installed them at all division points. Things were wild and woolly in the early days of the railroad. A common saying for the time was: "No heaven west of Clifton Forge, no God west of Hinton." (COHS.)

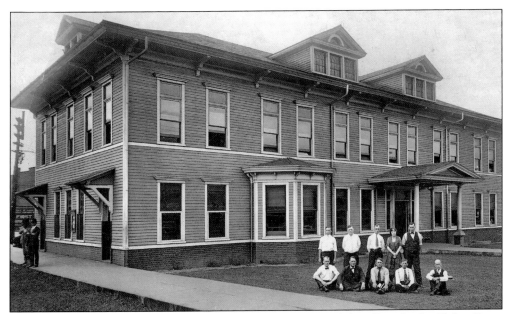

Clifton Forge Division Office Building, built around 1906, housed the offices for the Clifton Forge Division, which extended to Charlottesville in the east and Hinton in the west, as well as local functions such as yardmaster, road foreman, and so on. The group posing out front is likely the division superintendent and his staff. This is the track side of the building. (COHS.)

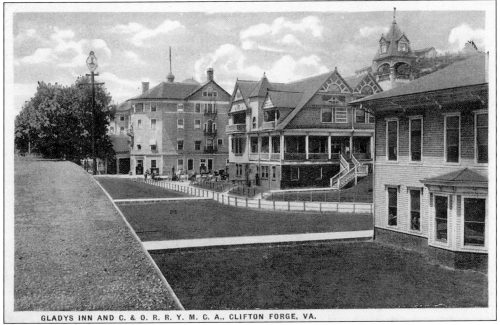

GLADYS INN AND C. & O. R. R. Y. M. C. A., CLIFTON FORGE, VA.

This is a postcard view of the three buildings from a later date. The passenger station canopy is in the left foreground, and the landscaping is filled in and lush. This would have been from the peak of this era, probably around 1920. It was at this time that passenger train ridership reached its peak as well. Affordable automobiles and better roads were about to change that forever. (COHS.)

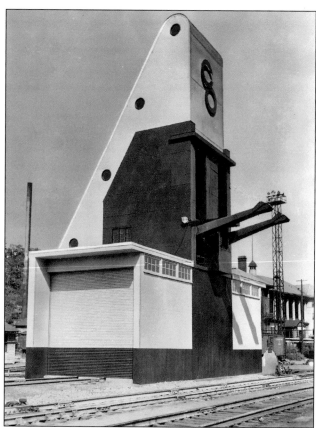

The streamlined coaling dock was built in 1947 for the C&O's legendary coal-fired, turbine-electric locomotive. This innovative coaling facility was located next to the main line and was designed to fuel the experimental turbine locomotive while it was stopped for passengers. The experiment failed, the diesel won, and this dock was a dormant landmark until it was torn down in 1962. (COHS.)

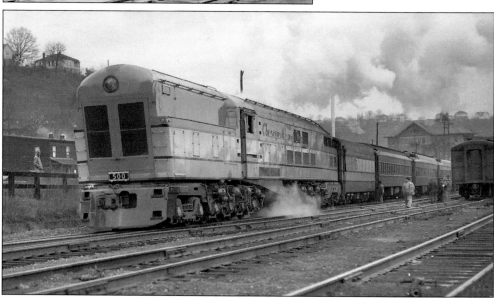

The 500, C&O's bold experiment, attempted to stave off the invasion of the diesel and keep coal as the primary locomotive fuel. In spite of impressive performance, there was no way for a steam boiler to compete with a diesel for ease and economy of maintenance. These amazing locomotives were based and serviced at the Clifton Forge shops. (COHS.)

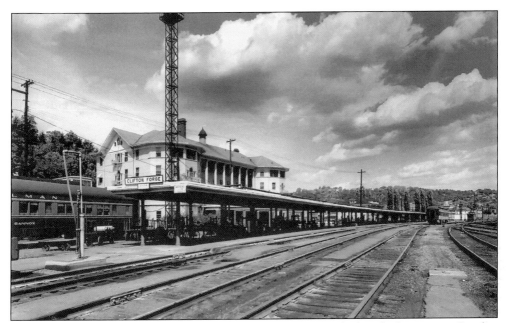

The Gladys Inn and passenger station is seen showing the canopy platform looking east in October 1956. To the left was a coach yard for parking passenger cars for repairs or staging. In 1930, the YMCA was torn down, and the inn became the Railroad YMCA. This was likely due to hotel guests shifting to the more modern and fireproof Hotel Jefferson. (COHS.)

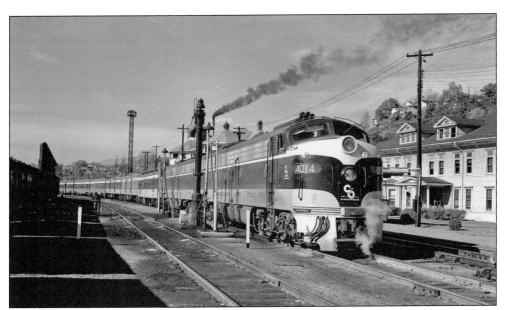

This image shows a C&O E-8 diesel passenger locomotive and train awaiting passengers in 1956. This was one of the C&O's beautiful, streamlined passenger trains from the 1950s era. It is sad that at the peak of their technology and service, the railroads were losing passengers to cars and airplanes. C&O ran these beautiful locomotives and first-rate trains until the beginning of Amtrak in May 1971. (COHS.)

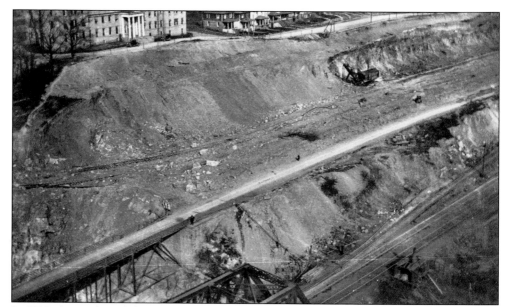

In 1922, the yards and shops were expanded extensively. There was nowhere to go but into the side of the mountain. Here, a steam shovel excavates the side of the hill in front of the C&O Hospital. In the foreground is the original railroad bridge for the main line, and in the middle are the road and bridge for automobile and horse traffic. (COHS.)

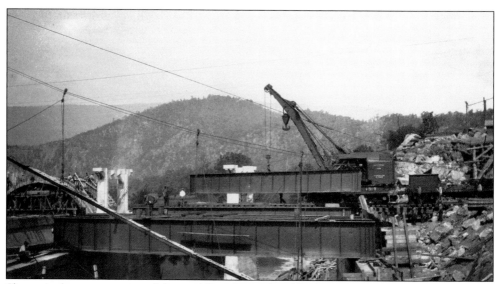

Shown is the construction of the world's widest railroad bridge. The bridge was 33 tracks wide and was built in 1922 to span the Jackson River in order to support the enlargement of the yard. Note the construction of the new highway bridge in the background. (COHS.)

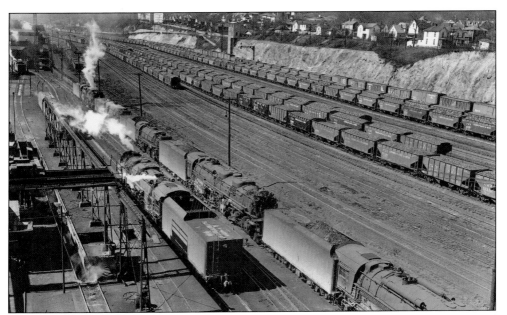

This photograph was taken from the top of the 1922 coaling tower. It shows the expanded yard in action as a storage and classification yard for coal hoppers. These trains would be organized to go to Newport News as "tides" designed to load specific ships at specific times. (COHS.)

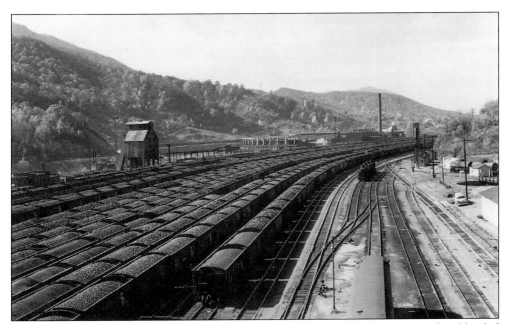

The C&O's reason for being was coal, coal, and more coal. Even today, huge trains of coal hauled by CSX continue to run through Clifton Forge on their way to Newport News for shipping overseas or along the East Coast of the United States. (COHS.)

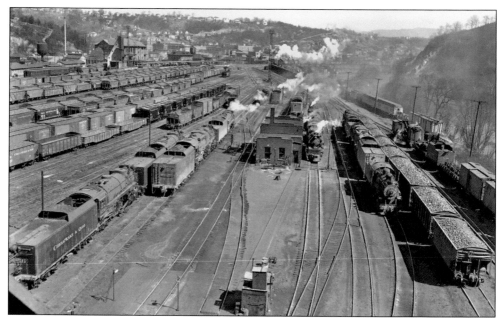

Clifton Forge was a major repair and servicing facility. This shows the beginning of that process. The building in the middle housed inspectors who would check out each locomotive or car that went into the servicing area and assign whatever work was needed. On the left are locomotives on the ready line, repaired, fueled, and ready to go. On the right, coal hoppers are headed to refill the coaling tower. (COHS.)

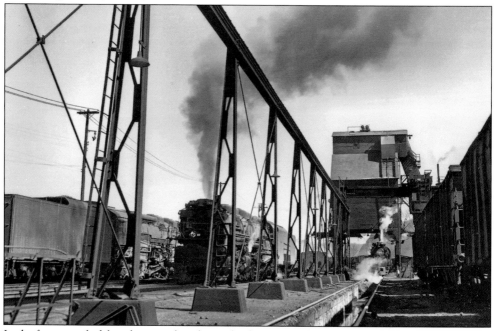

In the foreground of this photograph is the cinder dumping and removal area, and in the background is the coaling tower. Locomotives coming in for service would dump cinders into the pit at left that would be scooped up by the clamshell gantry crane and loaded into the hoppers at right. The 800-ton-capacity concrete coaling tower, built in 1922, still stands. (COHS.)

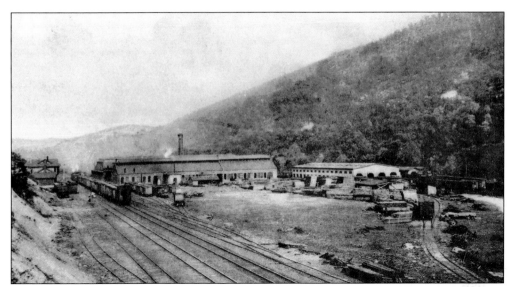

Here is an early view of the Clifton Forge shops around 1900. In this east-looking view, one can see the blacksmith and carpentry shop and its twin machine shop and engine repair shop. To the right is the car repair shop. At the left of the mainline tracks is the old West Clifton Forge passenger station, which was in use until 1897, when the Gladys Inn was built. (COHS.)

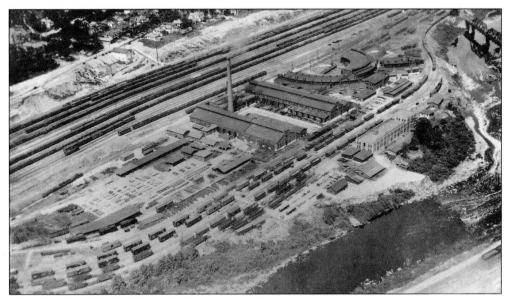

An aerial view of the Clifton Forge shops around 1945 shows the shop complex at its peak before diesel shops were built. Note the two large shops, the powerhouse with stack, the roundhouses, the open-air repair tracks, and the rebuilt stores building. The third floor of the stores building was the classroom for apprentice training. (COHS.)

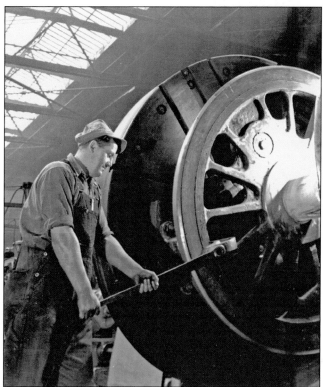

The shops were not just a place of work; they were a place of craftsmanship, and all who worked there had a great deal of pride in what they did. Here, machinist Bill Bursey is fastening a driving wheel to a lathe around 1947. (COHS.)

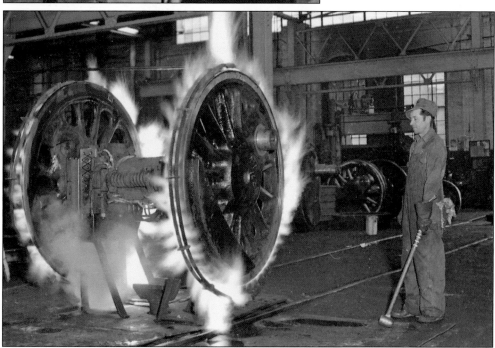

Here is a look inside the machine shops. Steel driving wheels had "tires" made of steel that wore out over time and had to be replaced. Machinist C.J. Swoope is heating a tire to be removed to expand it. He stands ready to take it off with the large hammer in his hand. (COHS.)

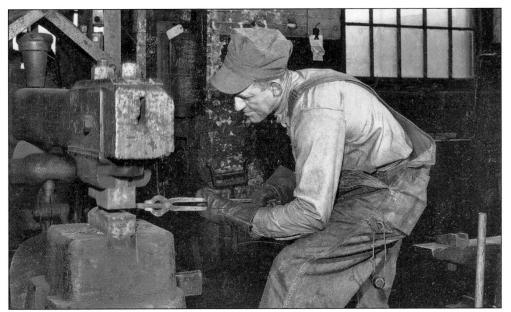

The shops at Clifton Forge could do everything needed to repair steam locomotives short of a complete rebuild. Unlike automobiles and diesel locomotives, each part of a steam engine was unique, custom fitted, and handmade. Here, blacksmith J.W. Downey is using a small drop hammer to forge a part for a locomotive that will be shaped by the machinists next door. (COHS.)

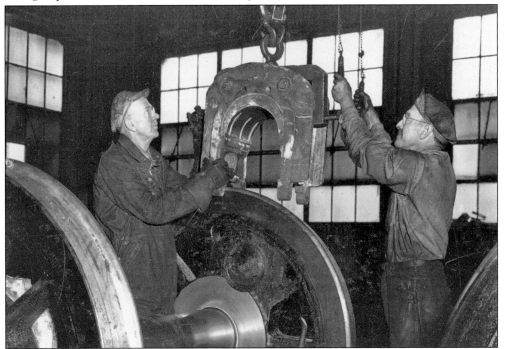

When locomotives would come in for major repairs, they would begin and end their journey in the erection shop, where boilers were lifted off the driving wheel. Here, machinists E.T. Vest and A.P. Meeks assemble a journal box to locomotive driving wheels prior to the frame being lowered into place in December 1948. (COHS.)

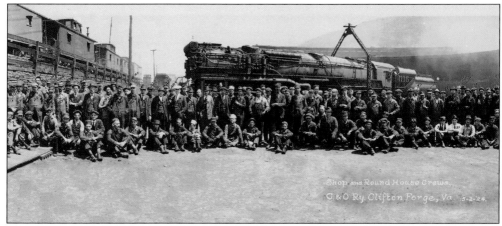

In 1924, the entire shift of the Clifton Forge shops posed on the turntable with the newest locomotive, the massive and powerful C&O class H-7 2-8-8-2. This would have been the equivalent of posing next to the latest jet aircraft today, as it represented the pinnacle of technology at the time. Note the cabooses stored on the track to the left waiting to be added to outbound freight trains. (COHS.)

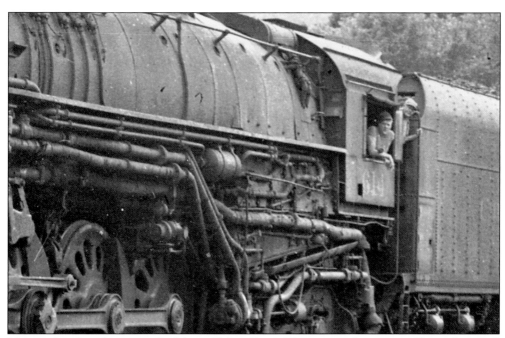

Many railroad road crews worked from Clifton Forge. The principal runs were "down the river" toward Lynchburg, "up the mountain" toward Charlottesville, or "over the Alleghany" toward Hinton. Here, engineer Jack Manner and brakeman Arthur Wood wait in a siding near Eagle Rock in 1952—in the last days of steam. Their locomotive is the famous C&O 614 Greenbrier-type locomotive, which is still in existence today. (COHS.)

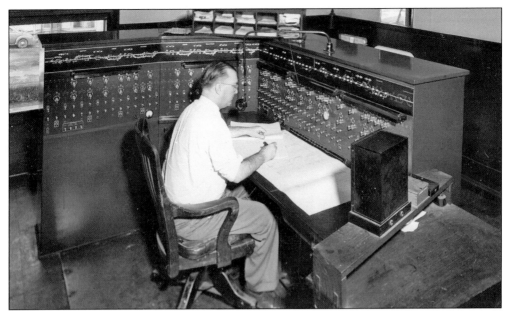

The dispatcher controlled the signals and switches on the Clifton Forge Division. This was set up in the Clifton Forge Division Office Building and controlled the line from Charlottesville to Hinton. (COHS.)

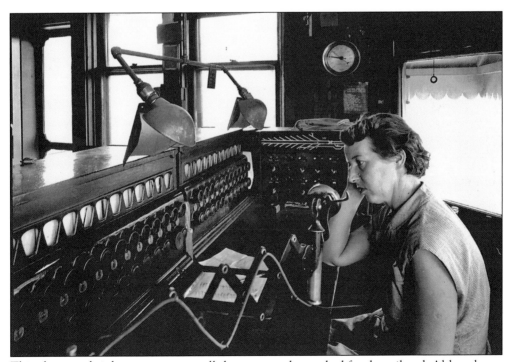

This photograph is here to represent all the women who worked for the railroad. Although not great in numbers, many women worked for the railroad and were accepted and respected. Here, Helen Lair is operating the hump yard in 1956 from the control tower (HY Cabin), which was located on the western side of town. (COHS.)

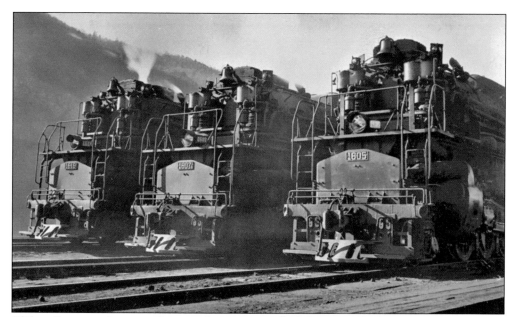

Clifton Forge was home to the great locomotive called the H-8 Allegheny, the most powerful steam locomotive ever built. It was specifically created to take 150 loaded coal cars over Alleghany Mountain; it also served in different areas, including pulling passenger trains at speed during World War II. Here, three are posed in Clifton Forge in 1942 for a publicity shot to be used in advertising to support the war effort. (COHS.)

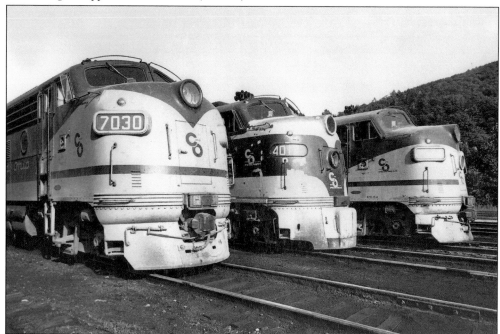

Only 10 years later, the diesel had replaced the steam locomotive. The C&O held on to coal-fired steam as long as it could, but by 1952, it shifted almost completely to diesel power. The last steam on the C&O operated in 1956, and with it went many of the skilled jobs at the shops. Here, two EMD F-7s and an E-8 pose at the same location. (COHS.)

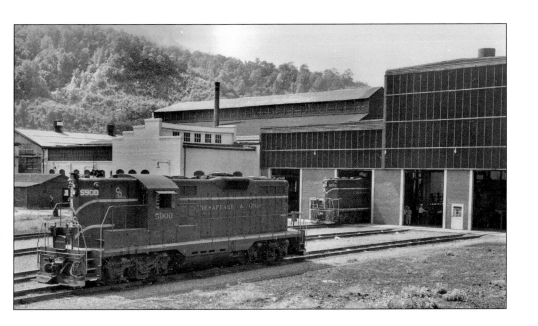

In 1952, the C&O built and opened a high-tech diesel servicing and repair facility in Clifton Forge. It was incorporated into the structure of the old shops buildings. It had four service bays, which allowed for work to be done on both the engines and undercarriage at the same time. It operated until 1987, when the shops were closed and services moved to Huntington, West Virginia, or Cumberland, Maryland. (Both, COHS.)

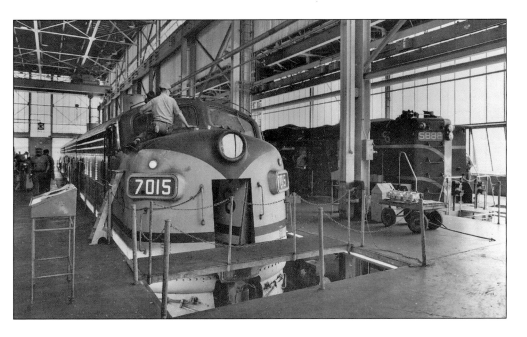

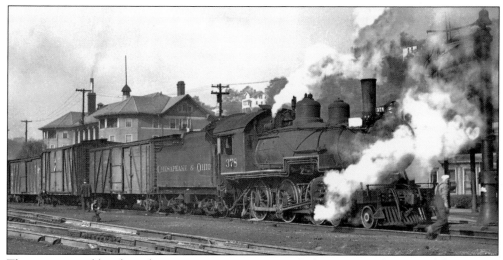

This scene was a blast from the past even in its own time. As late as 1948, this turn-of-the-century locomotive was used to haul freight down the Craig Valley Branch. Local Bill Colvin recalls working as fireman on this locomotive during the summer of 1947. It was replaced by a diesel locomotive around 1950. (COHS.)

It is gone but not forgotten. As a freight train heads east down the river, the conductor reaches out to capture his orders on the fly. The railroad still rolls through Clifton Forge but is much diminished from its former presence. Cabooses no longer run on the ends of trains, and steam is long gone, but the rhythm of the rails can still be heard and felt here day and night. (COHS.)

Four

THE COMMUNITY

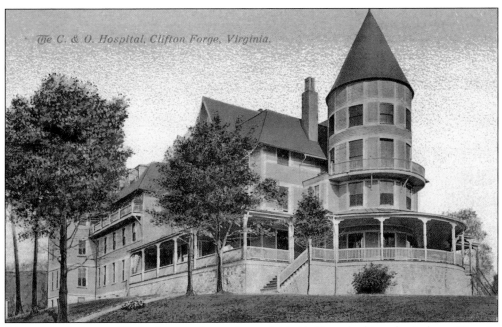

The original elegant Gladys Inn was located on a high bluff overlooking the Jackson River in West Clifton Forge. A new Gladys Inn was built near the center of the city, and in 1897, the C&O remodeled the original structure to make it into a hospital to take care of its employees and their families. (COHS.)

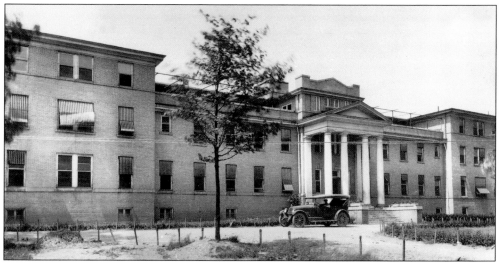

This C&O Hospital was built in 1917 to replace the older one. The new hospital of brick construction had a 90-bed capacity and three floors. It was quite modern for its day. The nursing school was established around this same time. (CFPL.)

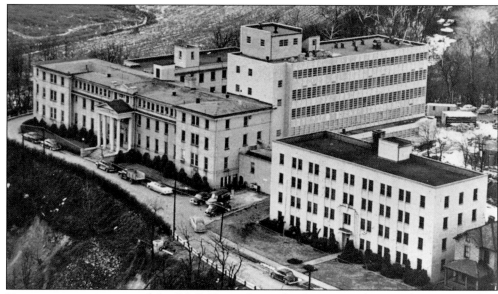

Here is a panoramic view of the C&O Hospital complex from around 1955. The east wing had just been completed, and the hospital now had a capacity of 205 beds. The main hospital building is seen on the left, with the west wing extending on the upper left. The east wing is the taller of the buildings in the center, and the building on the right is the nurses education hall and dormitory. (CFPL.)

John M. Emmett, MD, came to Clifton Forge in 1920 as chief surgeon of the C&O Hospital, was made chief surgeon of the C&O Railway in 1929, and was named a vice president of the C&O Railway a few years later. Dr. Emmett set high standards for the practice of medicine, resulting in the surrounding area receiving better care and the excellent reputation the C&O Hospital. (COHS.)

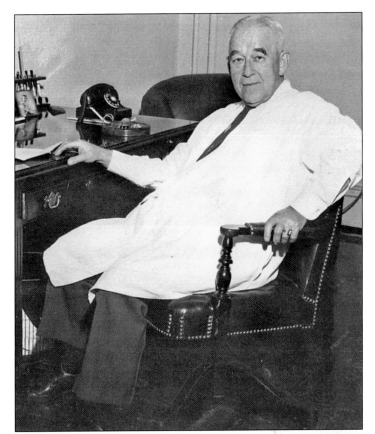

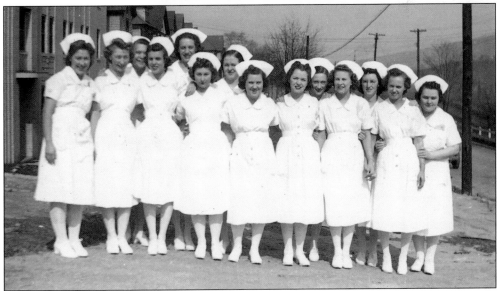

The C&O Hospital opened a school for nursing in 1916 that, except for a few years in the early 1930s, remained open until the early 1970s when Dabney S. Lancaster Community College started a nurses training program. The C&O Hospital graduated hundreds of nurses with a high percentage of certification by the state board. In this image, one can see the class of 1942. (COHS.)

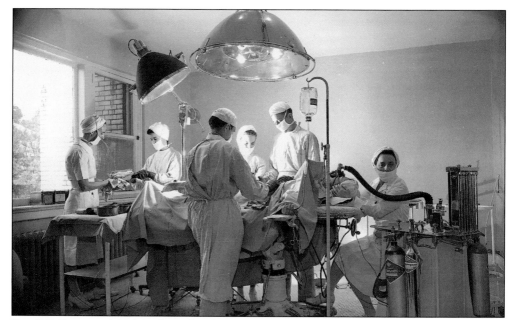

Drs. R.P. Bryan and S.M. McDaniel and nurses D. Camp, D. Mays, Jo Sirles, and Leila Payne are shown in a posed operation at the Clifton Forge C&O Hospital in 1946. This was a publicity photograph for the railroad demonstrating that the hospital was a first-rate medical facility. Its nursing school had a national reputation for turning out the finest nurses. The first pacemaker in the state of Virginia was installed here in 1959. (COHS.)

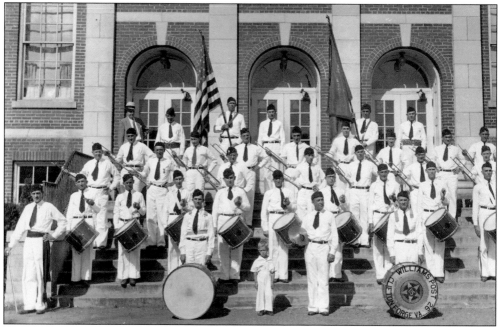

The American Legion sponsored a drum and bugle corps from around 1938 until the mid-1940s. Standing on the front steps of Clifton Forge High School, the full presence of the corps can be appreciated. This group participated in many functions around the city as well as marching in parades. (CFPL.)

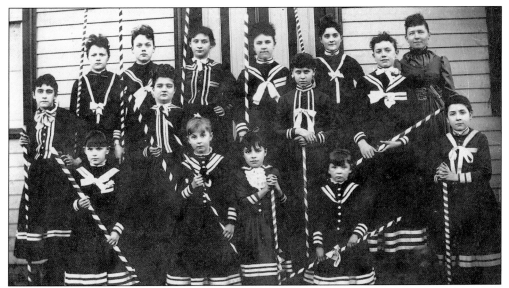

During the late 1800s and early 1900s, private schools were common. One was Miss Mamie Bryant's girls' school. Those pictured are, from left to right, (first row) Mrs. W. Boswell, G. Sweetwood, D. Harris, M. Sweetwood, and E. Bailey; (second row) O. Boswell, D. Tribbett, Mrs. A.B. Davies, and J. Payne; (third row) Mrs. F. O'Meara, A. Hatcher, M. Beasley, B. Johnson, L. Burks, and the headmistress, Mamie Bryant. (CFPL.)

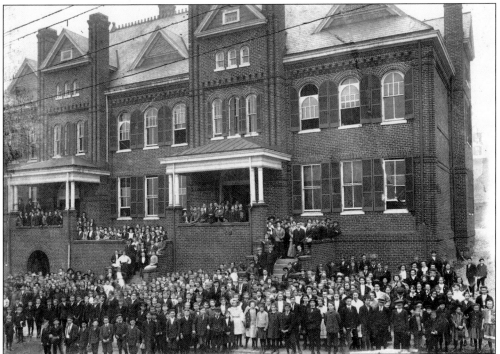

The original section of the Moody School was built in 1896 at a cost of $40,000. By 1907, the space was doubled at an additional cost of $20,000. Credit must be given to W.C. Moody, chairman of the school board, for donating the land and to W.W. Pendleton, who was superintendent of schools. (Courtesy of Debby Faulkenbury.)

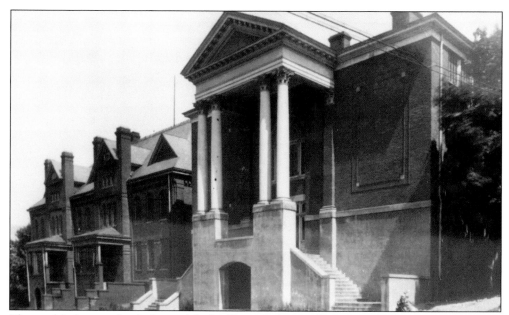

The need for better schools dictated the building of adequate housing to fit this need, and another school was built attached to the older Moody School. Although architecturally different from the earlier school, both schools are referred to as Moody School. For many years, the newer building was referred to as the "annex," the "new building," and other names. Over time, the complex was known simply as Moody School. (CKH.)

Seated on the front steps of the Moody School Annex is the class of 1922. Identified in this high school group are Frank Gallagher and James Hawkins (left and second from left, first row), Margery Tyler (Gallagher) (fourth from left, second row), Margaret Van Horn (far right, third row), and Louis Houff (second from left, fourth row). Many in this small class went on to very successful careers. The president of the class was Louis Houff. (Courtesy of Joan Gallagher Higgins.)

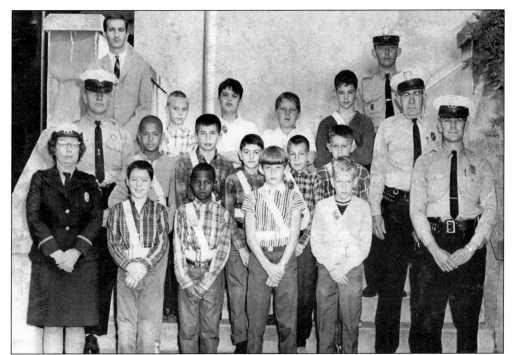

In 1968, the Patrol Boys in the fifth grade at Moody School would aid the Clifton Forge Police. Those pictured are, from left to right, (first row) Officer Janie Soloman, Mike Lawhorn, Mark Leisure, Dennis Duff, Jimmy, Leech, and Officer Hubert Sweet; (second row) Officer Jerry Caldwell, Albert Sledd, Ricky Warren, Ralph Lee Tucker, Tommy Slusser, Porky Paxton, and Officer Ryland Paxton; (third row) Principal Ralph Sebastion, Billy Lutz, Dean Pratt, Ricky Dobbs, Mark Pearson, and Officer Preston Faidley. (Courtesy of Kelly Slusser.)

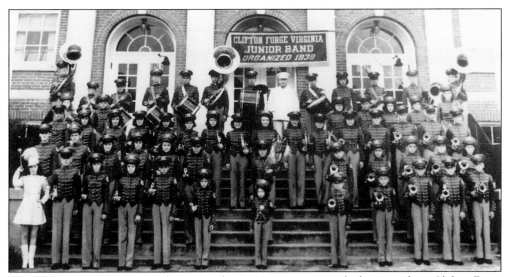

The Clifton Forge Junior Band, organized in 1938, was composed of citizens from Clifton Forge and the surrounding areas. The band, directed by G.T. Slusser, participated in many competitions and received many honors. It disbanded toward the end of World War II. (CS.)

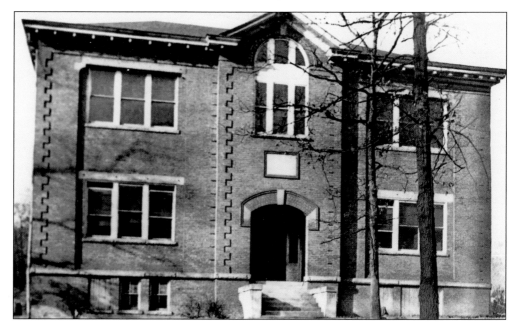

The Robert E. Lee School was built in 1912 to accommodate the growing population, especially in the western section of Clifton Forge. The school was first used as a high school and, later, became a primary school. It was closed in 1940 and was later torn down. (HB.)

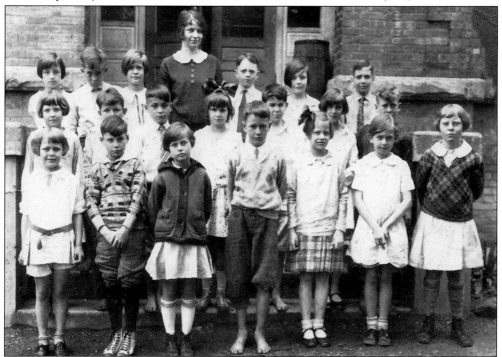

In 1928, fourth-grade students are on the steps of Robert E. Lee School, located on Fifth Street in the west end. There was no busing system then, so many children had to walk, catch a ride with a family member, or roller-skate to school. In this image, these children all dressed up in their Sunday best, except some came barefoot. (Courtesy of Josephine Dellinger.)

As the population of Clifton Forge grew, the city saw the need for a larger facility. Clifton Forge High School was opened in 1928 on Lowell Street, near the intersection of Commercial Avenue. Clifton Forge High School generated a strong sense of loyalty among its graduates. The Clifton Forge schools merged with Alleghany County in 1983, and this school continued to serve as Clifton Middle School until 2000. (Courtesy of John O. Dellinger Jr.)

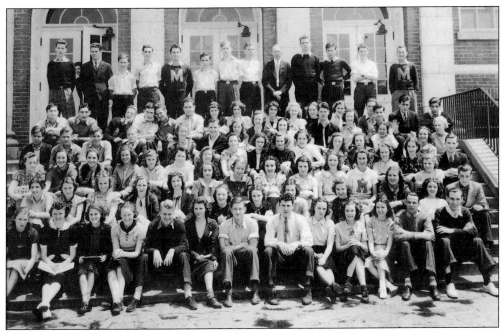

The class of 1938 was the largest class to graduate from Clifton Forge High School, with 98 students receiving diplomas in May 1938. A few additional students received their diplomas in summer school, which would have boosted this number to over 100. This class enjoyed a reunion every five years for the next 60 years. (Courtesy of Ed Dean.)

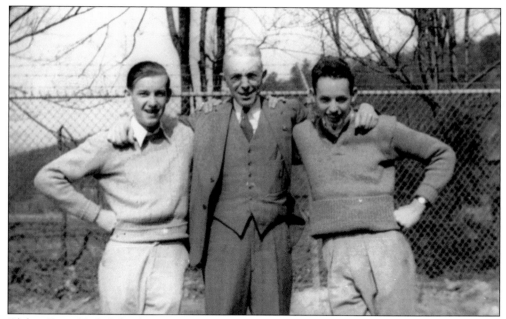

Clifton Forge High School's very respected, loved, and longtime principal V.J. Love is shown here with two students (Pedro Paxton on the left and Paul Higgins on the right) enjoying a spring day in 1942. Love was very involved in student life yet still maintained the necessary discipline. He is remembered for his patience, his kindness, and his willingness to cooperate with students and faculty. (Courtesy of Paul Higgins.)

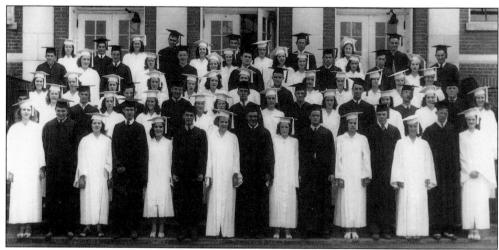

Members of the Clifton Forge High School class of 1942 are shown in their caps and gowns before their graduation exercises in June. This was one of the largest classes at Clifton Forge High School. At their 20th reunion, it was noted that most of the boys and several of the girls had served in the military during World War II, and all had returned safely. (Courtesy of Jean H. Manner.)

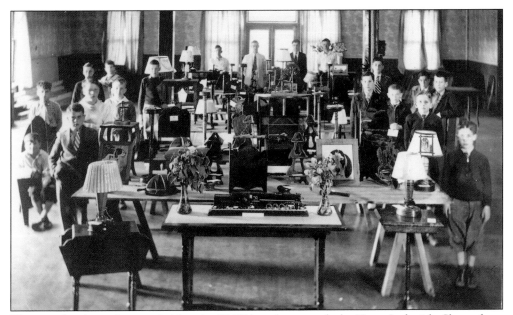

This woodworking class was held at the YMCA and was taught by Harry Leftwich. Shown here are the boys who are standing near the stations where they made small bookshelves, birdhouses, and many other attractive items made of wood. The YMCA sponsored many activities involving the youth of the area. (CS.)

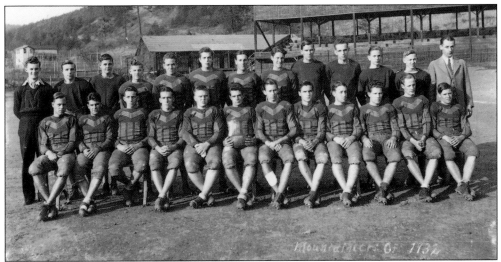

Clifton Forge has always supported local athletic events, whether school-affiliated or independent community teams. In this image, one can see the Clifton Forge High School football team of 1932. The last person on the right in the second row is Floyd S. "Pop" Kay. Pop Kay was responsible for molding the character of many young people, in addition to being a super coach. (CS.)

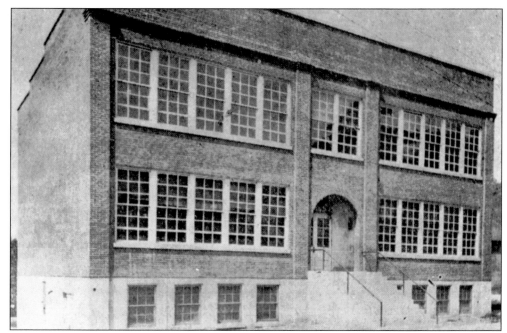

The Jefferson School was built in 1925. There had been several smaller schools in the black community, but the growing community and the desire to obtain a better education were always concerns. This school answered the needs of education after the merger with Alleghany County School System in 1983 and until the new school opened in the fall of 2000. (CKH.)

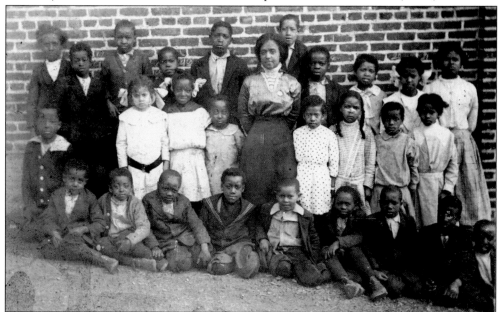

During the 1912–1913 school year, Ada Clark's class is pictured beside the first Jefferson School, which was constructed around 1902. This five-room school building was located in the 1000 block of Church Street. Ada Clark married George W. Lee in 1915, thus ending her teaching career, as ladies were not permitted to teach after marriage. Dr. S.G. Gibbs later purchased the building. (Courtesy of Gretel Lee Anderson.)

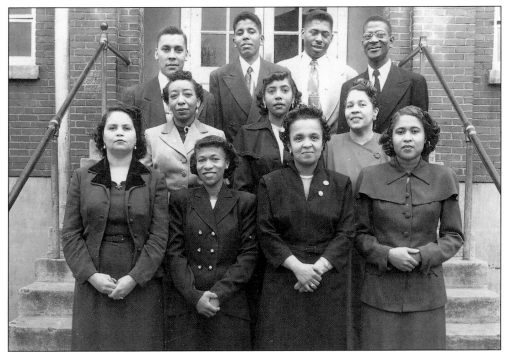

In 1952, the faculty of Jefferson High School included, from left to right, (first row) Evelyn Smith Nelson, Flora Gilchrist Shurn, Gretel Lee Anderson, and unidentified; (second row) Lillian W. Watkins, Agnes S. Berry, and Gertrude Atkinson; (third row) Ellis Long, unidentified, Lonzia J. Berry, and William C. Hill, principal. (Courtesy of Gretel Lee Anderson.)

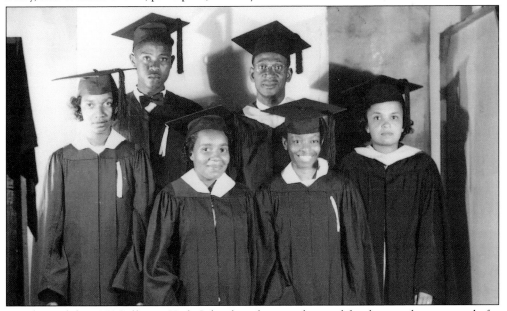

Members of the 1950 Jefferson High School graduating class and faculty members are ready for the graduation exercises. Those pictured are, from left to right, (first row) Ella Johnson, Patricia Callender, Agaua Pettis, and Gretel Lee Anderson, teacher; (second row) Herman Crawford and William C. Hill, principal. (Courtesy of Gretel Lee Anderson.)

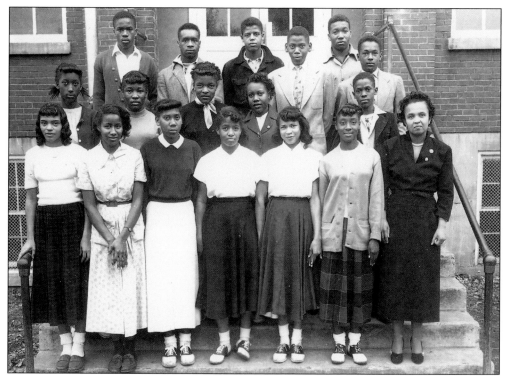

In 1955, Gretel Lee Anderson's Jefferson High School homeroom poses on the steps of the school. They are from left to right, (first row) E.M. Lewis, F. White, J. Watson, J. Burks, unidentified, S. Thompson, and Mrs. Anderson; (second row) S. Thomas, G. Pettis, D. Pettis, F. Smith, and V. Ross; (third row) B. Mills, P. Heighter, unidentified, T. Hill, unidentified, and K. Carter. (Courtesy of Gretel Lee Anderson.)

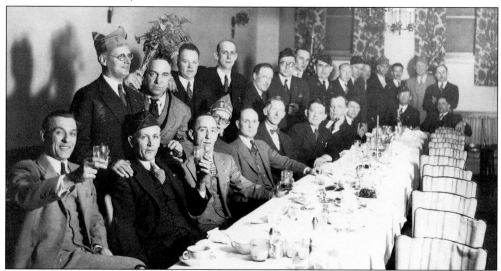

The Clifton Forge Last Man's Club, formed by veterans of World War I, was organized in 1933 with 59 members who met each year. A bottle of champagne was handed down from year to year, with the last remaining member drinking it to toast his departed comrades. In 1960, there were 17 in attendance; in 1970, there were 13. There are no living members remaining today. (CFPL.)

The Little Theater was organized in 1948, and for the next 10 years, it presented many first-class productions. Here, one can see the cast of *The Man Who Came to Dinner*. Many citizens in the community participated, and many more looked forward to productions and supported the effort. The plays were presented in the auditorium of Clifton Forge High School. (CFPL.)

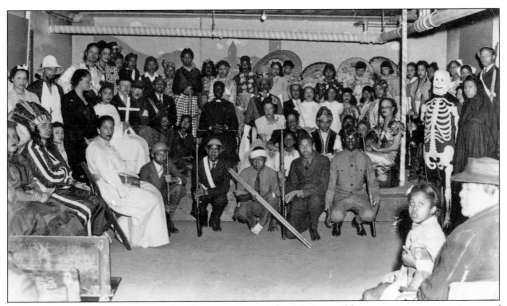

The black community organized a theater group in the 1940s, and here, one can see an image of the cast members in full costume. This effort was well supported by the community. (Courtesy of Ettrula C. Moore.)

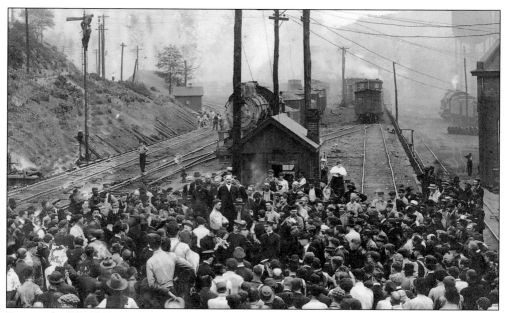

During the World War I era, 1918, Liberty Bonds were sold to support the allied cause. It was considered a patriotic duty to buy Liberty Bonds. Here, one can see A.B. Davies, a civic leader and former mayor, speaking to a group of men at the C&O shops, no doubt explaining the advantage of buying these Liberty Bonds. (CFPL.)

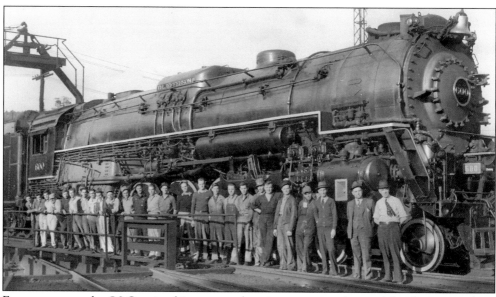

For many years, the C&O trained its own workers in apprentice classes. After four years, these men were certified in their trade, and almost all of them were hired by the C&O. Apprentice programs were available for machinists, electricians, pipe fitters, sheet metal workers, and a few car men. Pictured here is a machinist apprentice class from 1941 to 1942 standing in front of a passenger engine of the J-3 type. (Courtesy of Josephine Dellinger.)

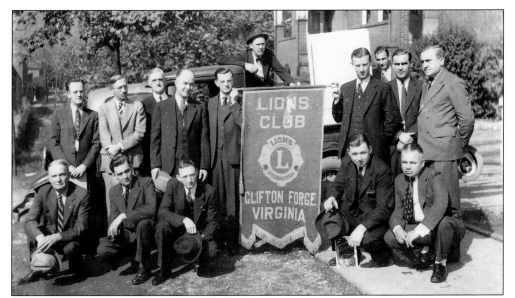

The Clifton Forge Lions Club, organized and chartered in 1935, is shown here in front of Moody School. Members pictured include, from left to right, (first row) two unidentified, Curtis Brown, Cletus Lawler, and Charley Copenhaver; (second row) eight unidentified, James Hawkins, and Preston Campbell. The Clifton Forge Lions Club is still active, providing reading glasses and hearing aids to the needy. (CS.)

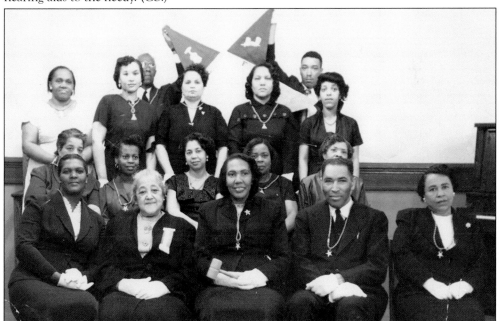

The Phyllis Wheatley Chapter No. 199 of the Eastern Star is pictured in the 1950s. Those pictured are, from left to right, (first row) Helen Womack, Rosamund Pierce, Georgia Meadows, Rev A.A. Womack, and Estine Brown; (second row) Thelma Jackson, Viola Wallace, Opalene Davis, Lucy Worth, and Kathleen F. Merchant; (third row) Rosa Ross, Elizabeth Clark, Evelyn Nelson, Pamela Turner, and Hilda Fountain; (fourth row) Paul Meadows and Robert Davis Jr. (Courtesy of Ettrula C. Moore.)

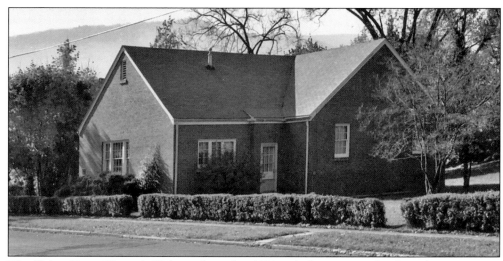

The Clifton Forge Woman's Club was formed in 1903 with the mission of making the community a better place to live. They built this club home in 1939, housing the city's only lending library until the city built its own in 1975. This was only one of the club's many important roles in the community. (Courtesy of Jean Ann Manner.)

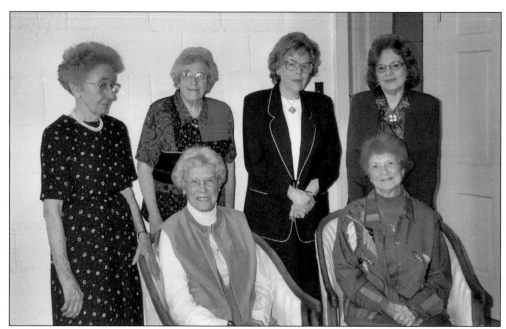

The Clifton Forge Woman's Club celebrated its 100th birthday in November 2003. In this photograph, one can see some of the past presidents who attended the celebration. Those pictured are, from left to right, (seated) Julia R. Bradley and Peggy Paxton; (standing) Dorothy Pullen, Davey Perry, Betty Sheets, and Betty P. Anderson. (Courtesy of Jean Ann Manner.)

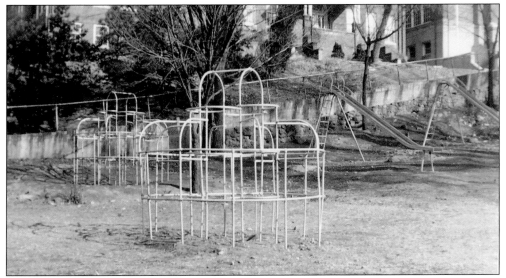

In 1949, one of the Clifton Forge Woman's and Junior Woman's Club projects was to purchase equipment for the grade-school playground at a cost in excess of $2,000. Here, one can see the mission accomplished, with Moody School in the background. (Courtesy of Clifton Forge Woman's Club.)

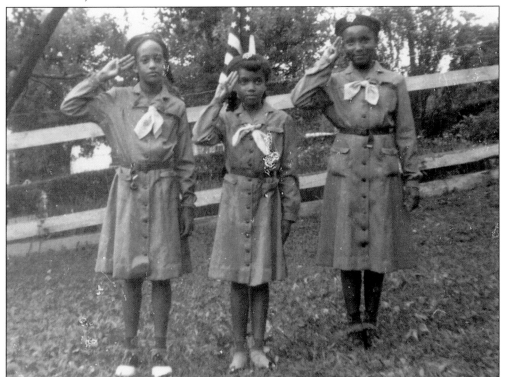

Girl Scouting has always been important in the lives of young girls, teaching patriotism and building character. Clifton Forge had many active Girl Scout troops. These three young ladies are saluting in the 1950s. They are, from left to right, Johnette Banks, Ettrula Clark (Moore), and Anelia Anderson (Atkins). (Courtesy of Ettrula C. Moore.)

Garland Huddleston was scoutmaster of Troop 2 from 1921 until 1948. During his tenure, scouting thrived in the area. Called "Chief" by his boys, he knew Scouting, and his leadership helped mold many young men into successful professionals. He was a friendly postman who checked on the people on his route, and they looked forward to his daily visits. (Courtesy of Jean H. Manner.)

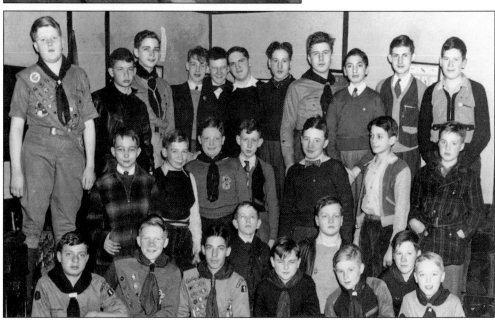

Boy Scout Troop 2, organized in 1919, is the oldest continuously sponsored troop in the United States. Scouts shown in 1938 are, from left to right, (first row) Walton Connelly, C.W. Bragg, Raymond McGehee, Lawrence Carter, Zimmy Major, David Wilson, Ben Goode, Sam Preston, and Buck Tyler; (second row) David Smith, Sam Clark, Straughan Burks, Richard Hoffman, Joe Halligan, George Kostel, and William Layne; (third row) Jack Manner, Danny Johnson, M.P. Lawrence, Bruce Lawler, Dick Sampson, Pierce Mahanes, John Huffman, Harry Shepherd, Billy Bernstein, Dick Larrick, and Bill Thompson. (Courtesy of C.W. Bragg.)

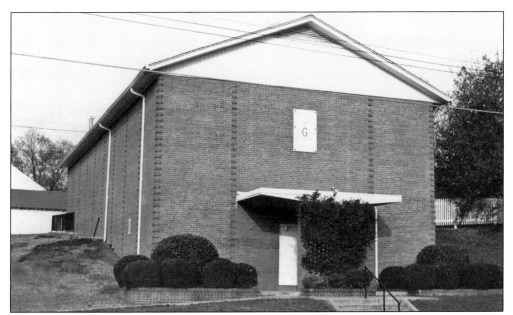

The Masonic lodge built its second structure on Commercial Avenue, completing it in 1961. This home provides a lodge hall on the upper level and a spacious dining room with a large kitchen on the street level. (Courtesy of John Hayes.)

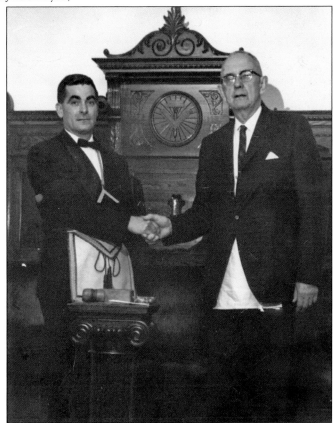

Robert P. "Bootie" Dellinger (left) was master of the Masonic lodge in 1963. In this photograph, he confers a 50-year pin on Dr. G.S. Hartley. Dr. Hartley was a specialist in internal medicine and a member of the staff at the C&O Hospital for many years before he moved his practice to the downtown area of Clifton Forge. (Courtesy of Josephine Dellinger.)

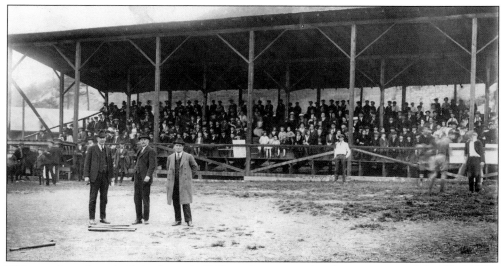

This grandstand was built in the early 1900s and accommodated spectators until the World War II era, when it was taken down. In June 1922, a Twilight Baseball League game is set to begin and is being introduced by city dignitaries. Those pictured are, from left to right, unidentified, L.A. Grubbs, the division superintendent of the C&O Railway; and A.B. Davies, mayor. (CFPL.)

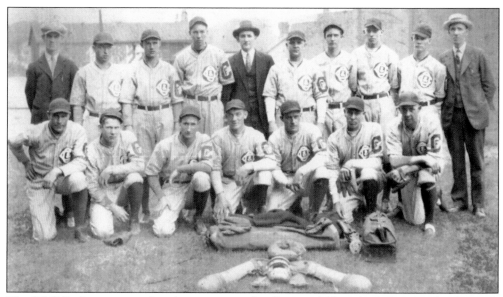

The C&O Railway was good to this city, not only offering jobs but also helping to develop such things as a baseball team and a band for its employees and their families. Here, one can see the team ready to take the field in the 1920s. Railroad baseball teams played at the professional level and would play major-league teams in exhibition games. (Courtesy of Marilyn Woods.)

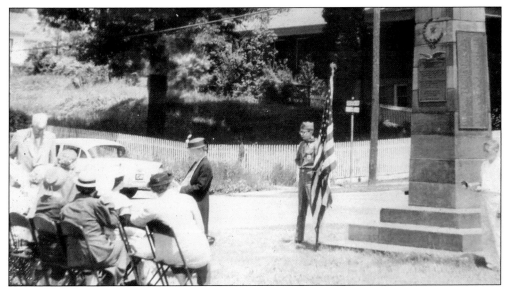

In the 1920s, a monument was placed in the west end of Clifton Forge as a memorial to those who died in World War I and was dedicated to the two Williams brothers, who gave their life for this cause. In this image, a group of citizens is conducting a Memorial Day celebration with the Boy Scouts participating. (CKH.)

When the highway was rerouted in the western part of Clifton Forge, this monument was relocated from the western end of Clifton Forge to an area downtown. The monument is the centerpiece of the appropriately named Veterans' Park on Main Street, which also contains memorials to those lost in other wars. Veterans' Park is the site of many patriotic ceremonies. (CKH.)

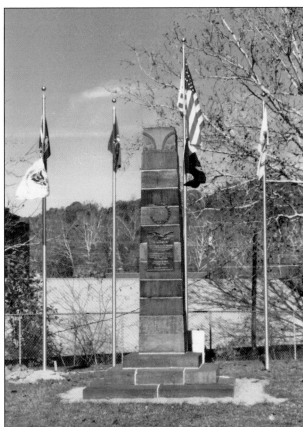

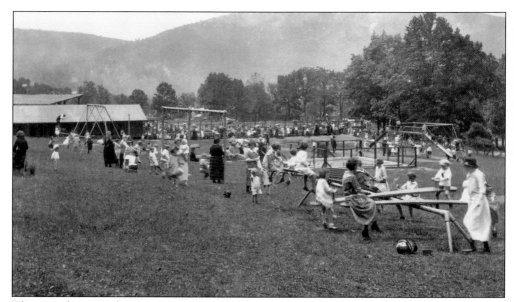

The city playground at Memorial Park was enjoyed by young and old alike during the 1930s. This image is looking south, and the roof of the grandstand at the ballpark can be seen in the background. (CS.)

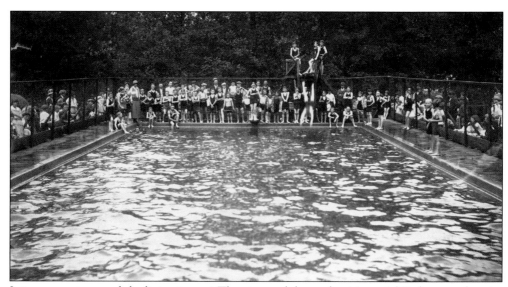

It is summertime, and the living is easy! The city pool, located at Memorial Park, was a favorite summertime hangout for the young people in the 1930s. It was closed during the 1950s. (CS.)

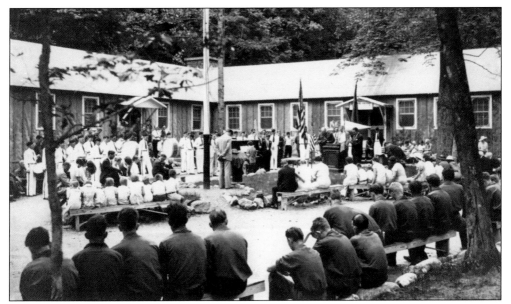

Among the projects given to the Civilian Conservation Corps (CCC) in the early 1930s was the development and building of state parks. Douthat State Park is among the best of these. In this image, one can see the camp headquarters of the CCC with the members participating in a Flag Day exercise. Douthat State Park has been a popular recreational site for both residents and visitors from the day it opened. (CS.)

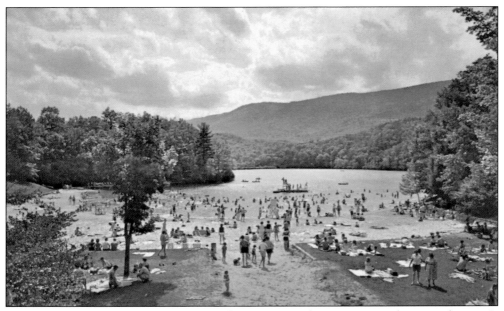

Douthat State Park has been a very popular attraction, drawing visitors from a wide area. It attracts in excess of 200,000 visitors a year. The beach at Douthat State Park is only one of many outdoor recreation features available there. This image shows the beach, lake, and diving tower. It is basically the same today as it was in the 1950s, when this image was made. (CS.)

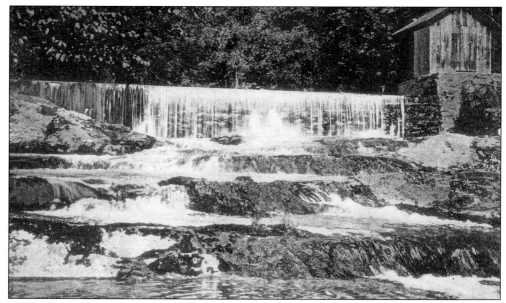

Capt. W.C. Moody and J.C. Carpenter Sr. were instrumental in establishing the first waterworks for Clifton Forge. In the late 1890s, Captain Moody purchased from the Williamson estate the right to pipe water from Smith Creek throughout the town. J.C. Carpenter Sr. constructed the dam. Gravity-fed by mountain springs and streams, the clean water flows into this "old," or upper, dam. (CKH.)

This is the lower dam on Smith Creek, just 3.5 miles north of the town. Beside the dam is the water and filtration plant, which treats and filters the water before sending it down into the town and surrounding areas. Smith Creek's watershed is composed of 7,600 acres in the George Washington National Forest. (CKH.)

Five

THE NEIGHBORHOOD

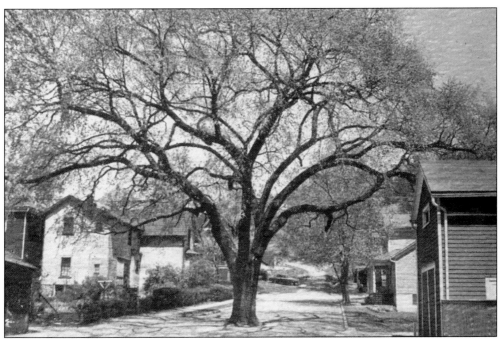

As Clifton Forge grew, so did the elm tree on D Street. The town became accustomed to driving around it, and it was known as the "grand old lady of Clifton Forge." Many times, the city council felt it was time to cut the tree down. In 1972, the elm was declared diseased and was taken down, much to the sorrow of many citizens. (CKH.)

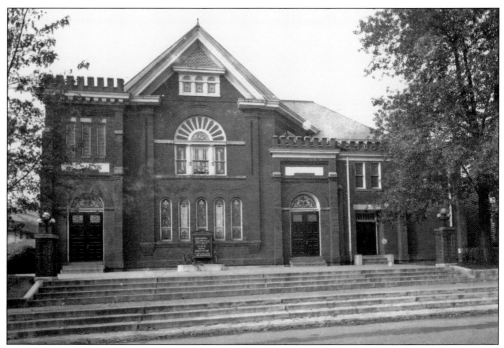

The Clifton Forge Baptist Church was organized in 1882 and built this lovely church on McCormick Boulevard in 1896. Since the time of its organization, it has been well attended, and its sanctuary is considered to be one of loveliest in the city. (CS.)

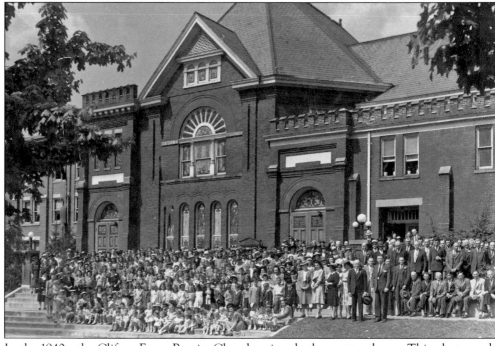

In the 1940s, the Clifton Forge Baptist Church enjoyed a large attendance. This photograph shows the full congregation on a Sunday morning. It also shows a fellowship hall and educational building that were added after the original portion was built. (Courtesy of Marilyn Woods.)

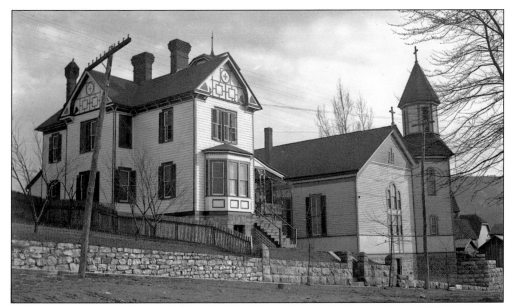

Built in 1889, St. Joseph's Catholic Church is located at 620 Jefferson Avenue. The rectory is shown on the left. The priest was Fr. Lawrence Kelly, formerly of St. Patrick's in Lexington. In 1930, the church was bricked and the porch entry was added. (COHS.)

St. Joseph's Catholic Church is shown with the entrance via stone steps around 1900. The entrance was used until 1930, when Rev. Joseph F. Govaert made improvements. Jefferson Avenue was not yet paved, and the sidewalk was wooden. The street was hard surfaced in 1922. (Courtesy of St. Joseph's Catholic Church.)

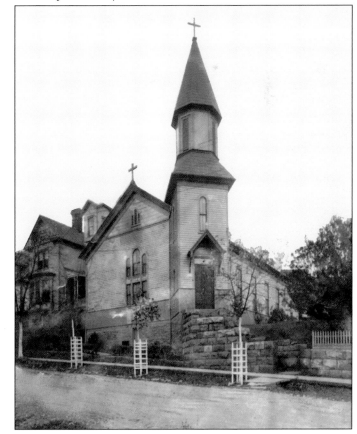

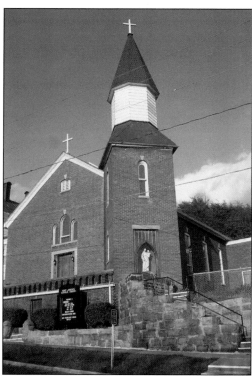

St. Joseph's Catholic Church is shown here after the brick exterior was added and the parish hall was constructed. In 1989, the congregation held its centennial celebration with Bishop Walter Sullivan, many former members, and priests in attendance. Many of the parishioners are fifth- and sixth-generation members. (Courtesy of St. Joseph's Catholic Church.)

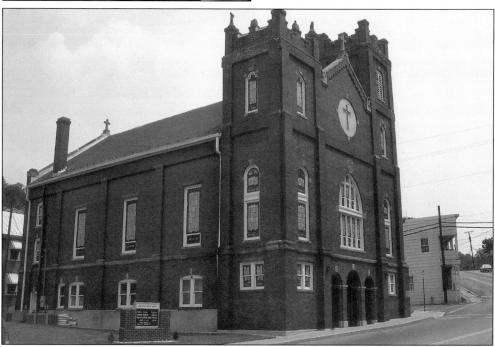

The Main Street Baptist Church was organized in 1895, purchasing the church formerly occupied by the Clifton Forge Baptist Church at the corner of Main and A Streets. At a later date, it rebuilt this beautiful structure on the same site. This was one of two churches organized and built by the African American community. It is always well attended. (CS.)

In 1881, the Clifton Forge Presbyterian Church built its first church on Church Street near the intersection with Jefferson Avenue. In 1891, the second church was built. The bell, which has been used in all three of churches the Presbyterians have built, still rings in the bell tower of the present church. It was given as a memorial for Sara Elizabeth Williamson. (Courtesy of Historical Room, Clifton Forge Presbyterian Church.)

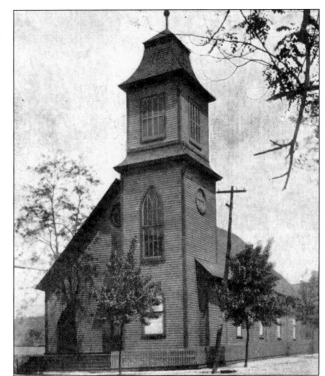

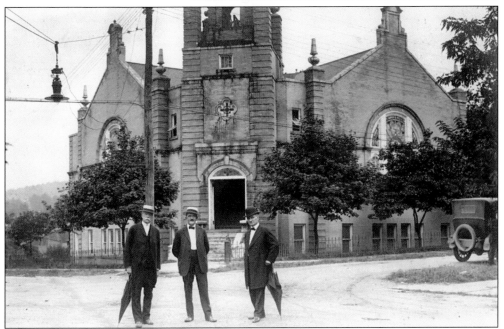

The current Clifton Forge Presbyterian Church was built in 1907. Located at Church Street and Jefferson Avenue, it was the third church built by the Presbyterians. In 1921, three former pastors celebrate the 40th anniversary of the church. Those pictured are, from left to right, Rev. Dr. E.W. McCorkle, founding pastor; Rev. James E. Cook; and Rev. Dr. L.H. Paul, the then-current pastor. (Courtesy of Historical Room, Clifton Forge Presbyterian Church.)

Clifton Forge Presbyterian Church conducted a Bible school each summer. The Bible school would last three weeks for three hours each day. This program was quite popular and was attended not only by Presbyterians but also by others in the community. In 1932, students gather on the lawn of the church, located on the Jefferson Street side. (Courtesy of Historical Room, Clifton Forge Presbyterian Church.)

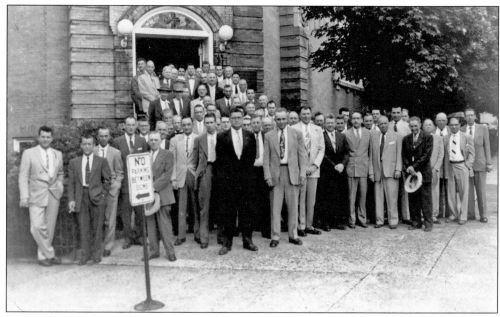

During the 1940s and 1950s, there was competition among the men's Bible classes of the protestant churches, with attendance recognition on Monday in the local paper. The men of Clifton Forge Presbyterian gather on the front steps of the church in 1950. (Courtesy of Historical Room, Clifton Forge Presbyterian Church.)

The first Methodist church in Clifton Forge, a wood structure with double doors and a steeple, was built at 612 Church Street in 1884. Prior to this, the congregants, including folks of other denominations, met in private homes and the Union Meetinghouse, near today's Main Street Baptist Church. In 1910, the original church was converted into a house, which still stands. (Courtesy of Central United Methodist Church.)

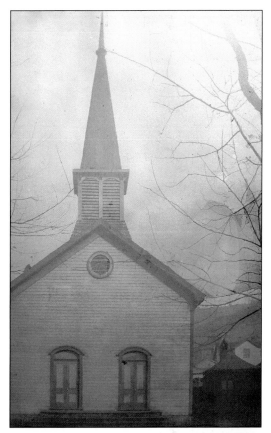

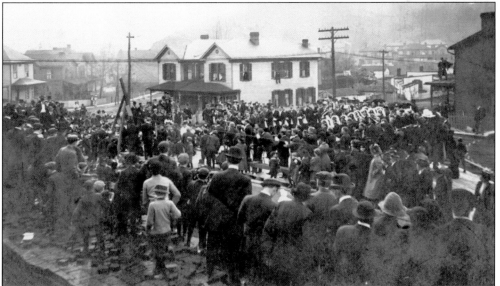

On a pleasant day, March 9, 1909, around 1,000 people watched the laying of the cornerstone for Central Methodist Episcopal Church South. The Masonic Lodge of Low Moor presided over the occasion, assisted by the Alleghany Commandery Knights Templar. Music was provided by the Clifton Forge Alpine Band. (Courtesy of James Ballou.)

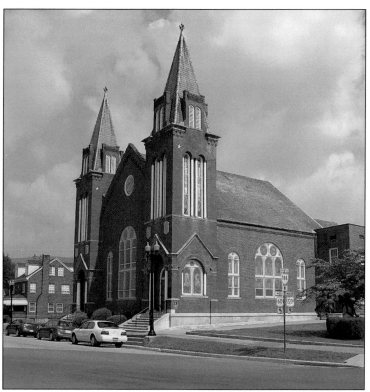

Completed in 1910, Central Methodist Episcopal Church South, at the corner of Main Street and Commercial Avenue, replaced the 1884 church. It is an example of the Neo-Romanesque architecture, featuring bell towers, round arches, surface decoration, and stained glass windows. The fire of April 3, 1949, did not destroy the exterior, but it did alter the sanctuary's interior, which now has a large barrel vault lighted by stained glass windows. (Courtesy of Central United Methodist Church.)

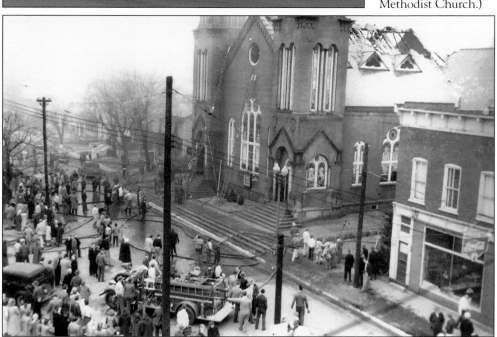

Ironically, on Sunday morning, April 3, 1949, the bulletin board in front of Central United Methodist Church announced the title of the sermon, "It Is Finished," as a raging fire raced through the building. The Clifton Forge and Covington Fire Departments battled the blaze for five hours. Amazingly, the exterior walls and most of the stained glass windows survived. (CKH.)

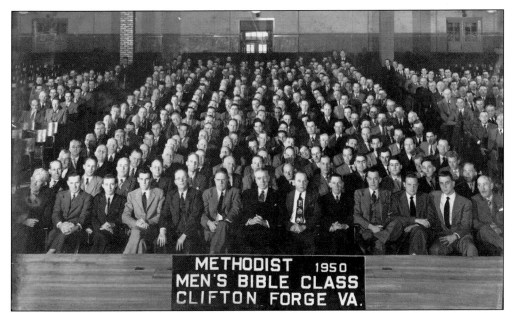

Over a two-year period following the fire in 1949, services at Central United Methodist Church continued with the help of other churches, the armory, and the men's Bible class in the Clifton Forge High School auditorium (seen here). Services in the church resumed on April 21, 1951. The restoration cost $190,000. When the church was rededicated in 1955, it was debt free, which reflected the generosity of the congregation and others. (CS.)

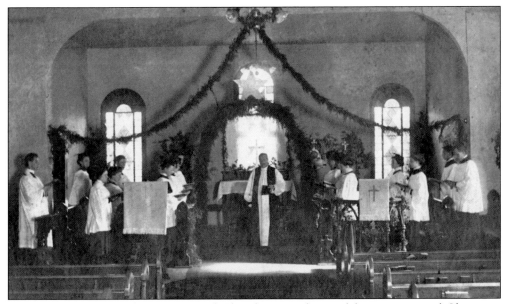

The interior of St. Andrew's Episcopal Church is seen here celebrating a special Christmas worship service. This image likely was made in the 1910s or 1920s. It allows the viewer to share with the parishioners the warm spirit of the holiday season. (Courtesy of St. Andrew's Episcopal Church.)

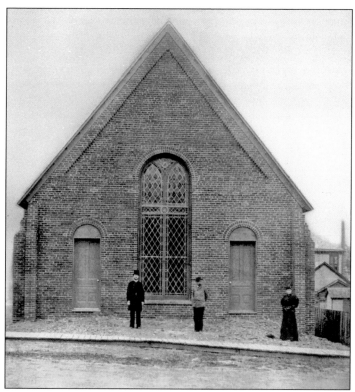

St. Andrew's Episcopal Church was organized in 1890, and the church was built in 1892 on McCormick Boulevard on a lot that was a gift of Col. James A. Frazier. This picture of St. Andrew's was taken in October 1895. Rev. H.L. Wood was minister of the church from 1893 to 1895. (Courtesy of St. Andrew's Episcopal Church.)

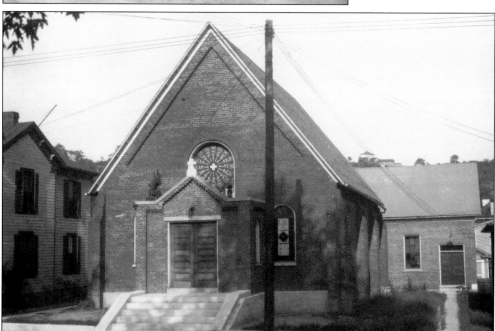

St. Andrew's Episcopal Church, organized in 1890, is seen here in the 1960s. Remodeling placed one double door in the center of the church, rather than the original two separate doors. This church added a fellowship hall at the rear that is widely used by organizations in the community. (CKH.)

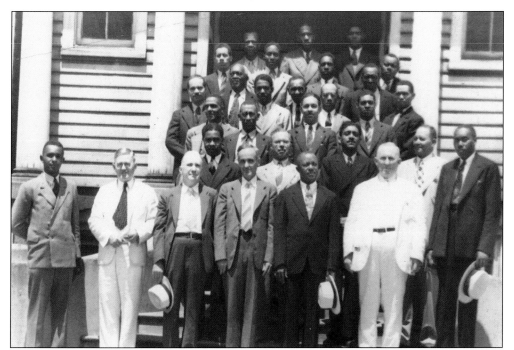

In the late 1930s, the Men's Sunday School Class of the First Baptist Church met with representatives of other Protestant churches in Clifton Forge. Pictured here are, from left to right, (first row) Rev. Hugh Austin; Rev. Dr. Tipton C. Bales, pastor of Clifton Forge Presbyterian Church; unidentified; Dr. William P. Gilmer; unidentified; Rev. James Gardner; and unidentified. (Courtesy of Ettrula C. Moore.)

The Community Choral Club, active in the 1940s, was composed primarily of African Americans. The club's concerts were presented in the local churches. Here, a concert is depicted in the First Baptist Church. (Courtesy of Ettrula C. Moore.)

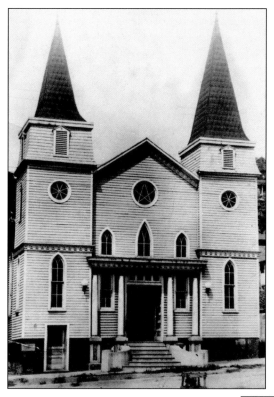

According to records, the First Baptist Church was the first church to organize in Clifton Forge. This African American church met in private homes until it was able to build a small church on Verge Street. As the congregation grew, Edmund Scott donated the land on Church Street, and the handsome church, which is still used today, was built. (Courtesy of Ettrula C. Moore.)

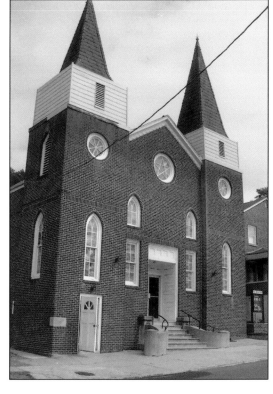

Organized in 1878, the First Baptist Church was first a wooden structure. As attendance grew, members made the decision to brick over their lovely building in the 1950s. First Baptist Church continues today as a very active, primarily African American church. (Courtesy of Ettrula C. Moore.)

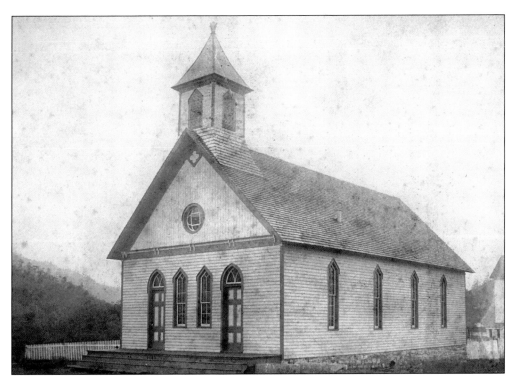

The First Christian Church began in 1885 and formally organized in 1886. In this photograph, one can see the first place of worship, built on Cary Street near the center of railroad activities in the town. The C&O donated the land, and the members were able to pay for the church. This little church served its growing congregation well. (Courtesy of First Christian Church.)

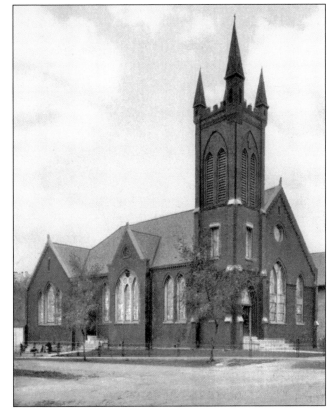

In 1907, because of its growing congregation and the noise from the fast-growing railroad nearby, the members of the church sought a more desirable location. They selected a site on the corner of Church Street and McCormick Boulevard, where it remains an active church today. (Courtesy of First Christian Church.)

In 1922, the men's Bible class at the First Christian Church was well attended. Located on the corner of Church Street and McCormick Boulevard, the members felt they had chosen the site for their church well. This photograph is looking north on McCormick Boulevard. (Courtesy of First Christian Church.)

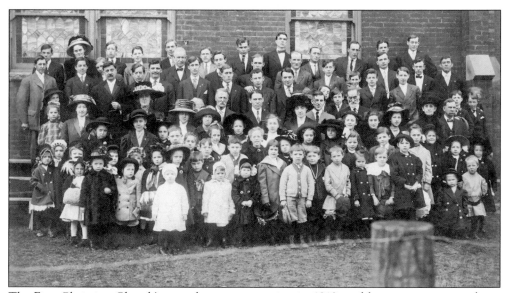

The First Christian Church's attendance was growing in 1910, and here, one can see a large number of Sunday school participants. They would soon outgrow the facility and need to build an addition for Sunday school attendance. (Courtesy of First Christian Church.)

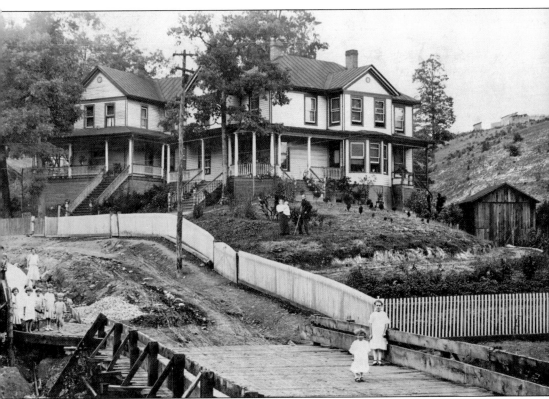

Owned by John C. and Cora G. Lane, standing in the yard, this home on Roxbury Street faces northeast. Their daughters, Dorothy and Mary Catherine, are standing on the bridge, and on the left are neighbor children Polly Plunkett, Hattie Driscoll, and Jack Downer. This photograph was taken in 1918. The street was not paved, there was no sidewalk, and the bridge was wooden. (Courtesy of Vivian Sutphin.)

This house was built around 1890 by Capt. William C. Moody, a Confederate veteran. Captain Moody, of Moody and Carpenter, was instrumental in building of the town's water system. He donated land for Moody School and was an active businessman. (Courtesy of Jean H. Manner.)

Nicely Funeral Home has been located at 405 Alleghany Street since 1945. J.C. Carpenter Sr. built this home in 1898. Roy Nicely remodeled it in 1945 to make an up-to-date funeral home that still retained the beauty and integrity of this lovely home. It is still operated by his son-in-law Bob Slusser and his grandson Tommy Slusser as Nicely Funeral Home. (Courtesy of Kelly Slusser.)

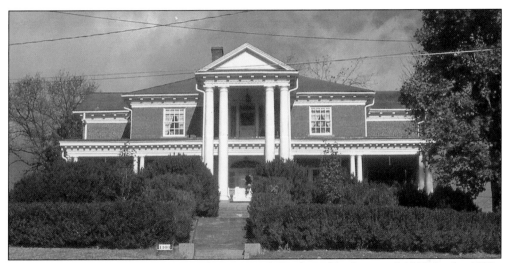

Hillcrest is a lovely home at the top of McCormick Boulevard built around 1915. In the 1920s, Dr. John M. and Annie Cone Emmett bought it. It was occupied by Dr. Emmett and his family and then by his daughter and son-in-law, Drs. Meade C. and Julia Emmett Edmunds, until the 1990s. (Courtesy of Hammonds/Nancy Rutherford.)

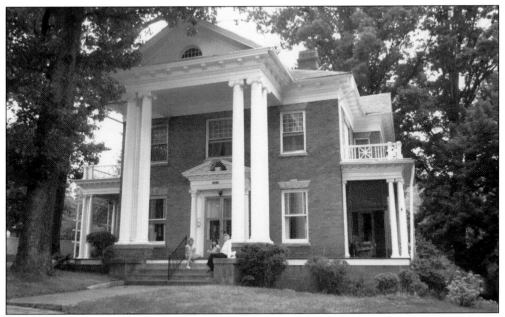

This stately home belonged to Walter K. and Edna Courts Smith and their family for many years. Walter Smith was a prominent businessman in the developing years of Clifton Forge, being an associate of Smith-Rule and Smith-McKinney, among others. The home dates back to the late 1890s or early 1900s. The beautiful white columns give it a look of grandeur that it retains today. (CKH.)

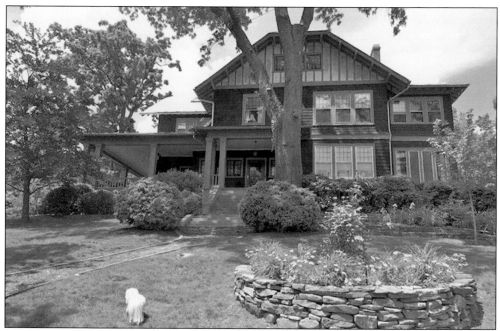

Ridgely is a Tudor-style home with an Arts-and-Crafts influence. It was built in 1902 by Ambrose and Rives Cosby Ford and has a large garden on the corner of First Street and Bath Street. The exterior of this lovely home has remained virtually the same, and the beautiful gardens have been restored. The home is currently occupied by Dr. Don and Johnette Roberts. (Courtesy of Don and Johnette Roberts.)

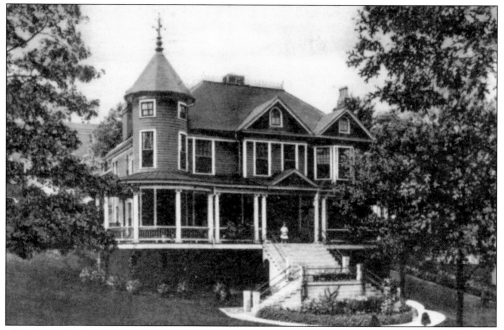

This beautiful Victorian home at 304 Alleghany Street was built in 1896 and was bought by Charles F. Sentz in 1898. The Sentzes added onto the home over the years. It stands today in good condition and is owned and occupied by Oliver and Tamara Reid. (Courtesy of Oliver Reid.)

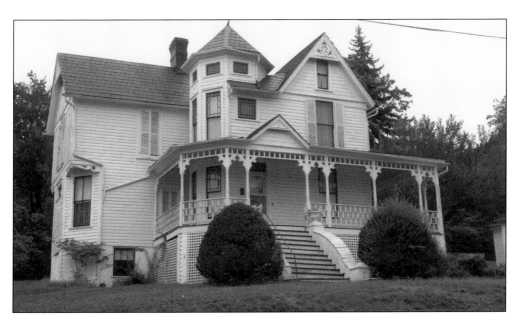

These two splendid homes are representative of the style of homes built in the 1890s and early 1900s. At this time, Clifton Forge and West Clifton Forge were separate towns, merging in 1906 into one city. The Robert James home at 132 Alleghany is seen above, and the A.B. Davies home at 116 Alleghany is viewed below. Davies was mayor of West Clifton Forge and went on to serve as mayor of Clifton Forge after the merger. Homes built during that era are aesthetically beautiful and built with sound construction and quality materials. (Both, CKH.)

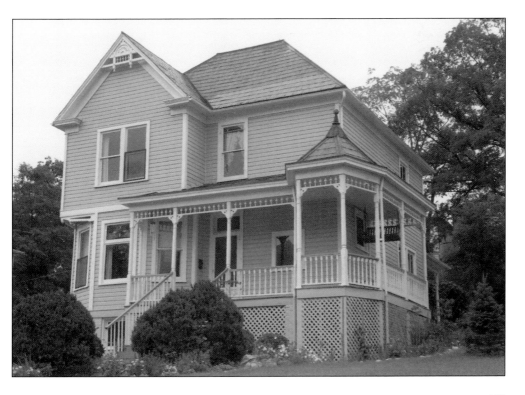

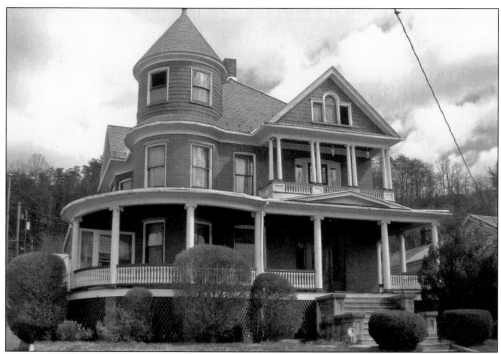

This house was built around 1900 at 900 Church Street for Edmond S. Scott, who operated a coal yard and had many rental properties. His sons Earnest and Harry Scott designed it. Edmund S. Scott, a successful businessman, owned the farm that became Forest Hills and the property that is now Linden Park. His granddaughter Ernestine M. Scott resides in the home place. (Courtesy of Ernestine Scott.)

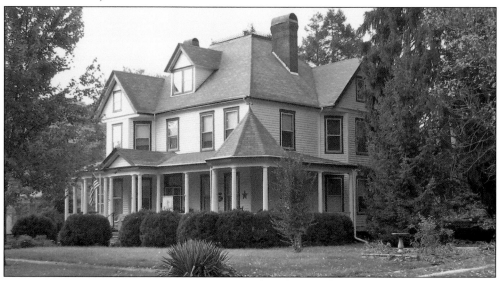

This lovely home was contracted by the Westerman family to be built in 1901–1902. The center part of the house was built on Girard Street. After the Westermans acquired the lots on McCormick Boulevard and before building was complete, the house was moved to the location where it now stands on McCormick Boulevard. Ruby Murphy and her daughter and son-in-law, Debby and Len Faulkenbury, live there now. (Photograph by Josephine Dellinger, courtesy of Ruby Murphy.)

Six

THE JOURNEY CONTINUES

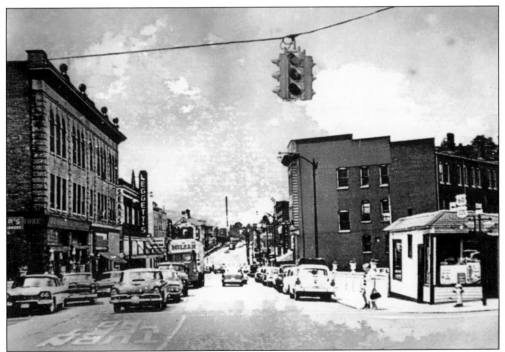

This image is of downtown in the 1950s, looking west down Ridgeway Street. This view shows Clifton Forge at the peak of its commercial development. Ridgeway Street was also the busy thoroughfare US 60, which ran directly through town and was a major route for travel and truck shipping prior to the development of the interstate highway system. On the left is Leggetts Department Store, and on the right is the legendary hot dog stand.

The Alleghany Highlands Arts and Crafts Center, organized in 1983 by a group of 40 citizens, opened its admission-free doors in 1984 at 475 East Ridgeway Street. Spearheading downtown revitalization, the center, with its cultural attraction signs on Interstate 64 and US 220, draws an average of 10,000 visitors annually from 34 countries and all 50 states. Organized for educational purposes, this not-for-profit corporation, staffed by a paid executive director and 80 volunteers, has fulfilled its mission with a continuing procession of 360 exhibits featuring the work of local, regional, national, and international artists; a shop, offering for sale the work of 240 juried area and regional artists and craftsmen; an educational outreach program that annually cosponsors, with the Virginia Commission for the Arts, an Artist-in-Education Residency to the area high schools; and ongoing gallery tours, classes, and workshops. The center is a tax-paying member of the business community while providing an enriching environment for citizens and visitors of all ages. (Courtesy of the Alleghany Highlands Arts and Crafts Center.)

Shelving in the art center shop once held books in the library of the old C&O Hospital School of Nursing. When the school was torn down in 1983–1984, the center's volunteers salvaged them and reinstalled them in the shop. Here, they have continually displayed the work of area and regional artists and craftsmen. (Courtesy of Alleghany Highlands Arts and Crafts Center.)

The center's professionally designed gallery is a venue desired by area, regional, and national artists. Anyone may enter the Fall Festival Exhibit, and area high school students may show their work every spring. All other exhibits are by invitation, thus providing enhanced educational opportunities for viewers and local artists. Here, Joni Pienkowski's *Transient Model* peers out at viewers. (Courtesy of Alleghany Highlands Arts and Crafts Center.)

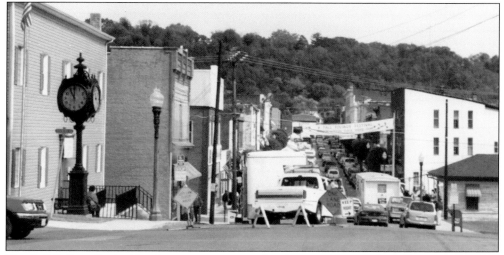

The Fall Foliage Festival has been a major event for the past 40 years. Initially sponsored by a civic organization, the Shriners began sponsoring it a few years later and continue to do so today. The festival draws over 40,000 visitors to the area, and the crowds grow each year. The streets are blocked off to make room for vendors, allowing one lane of traffic in either direction. (CKH.)

Clifton Forge opened its first public library in 1975 and, a few years later, added a meeting-conference room on to the building, which was dedicated to Michael Armstrong, its capable director. Library facilities were previously offered to citizens by the Clifton Forge Woman's Club for more than 70 years prior to the establishment of the library. (CKH.)

In 1964, the Virginia General Assembly created the Clifton Forge–Covington Branch of Virginia Polytechnic Institute. The State Board of Community Colleges assumed control in 1967, and it became Dabney S. Lancaster Community College (DSLCC). Dr. Donald Puyear was the first president, followed by Dr. Jack Backels (right). During Dr. Backels's long tenure (1969–1995), the forestry technology, nursing, computer technology, and criminal justice programs were established. The Scott Hall Library, the Moomaw Student Center, and National Guard Armory were built. Because of his many accomplishments, the administration building (below) was named Backels Hall in his honor. Dr. Richard Teaff became president in 1995, and during his tenure, more programs have been added, including the following: forensic science, advanced manufacturing, massage therapy, medical services, and culinary arts. (Both, DSLCC.)

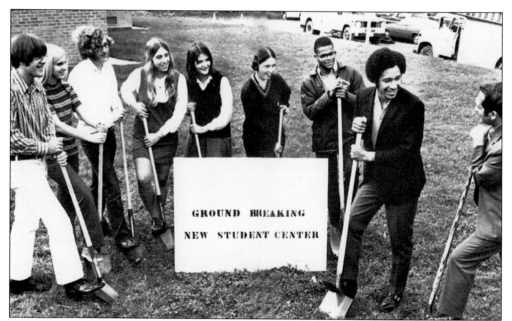

In 1971, these unidentified DSLCC students break ground for the Moomaw Student Center along with college president Dr. John F. Backels (far right). This building has been used for many activities, including a bookstore, dinner theater productions, art exhibits, lectures, wedding receptions, reunions, and various programs. Today, the recently enlarged building includes classrooms and a state-of-the-art kitchen. (DSLCC.)

The Scott Hill Retirement Community was built on the site of the old C&O Hospital in 1984. The rear section incorporates the original 1955 wing, but the rest of the building is new. It is a full-service facility with 140 apartments for people who are 64 or over or physically handicapped. It is an important asset to the area with close proximity to downtown Clifton Forge and the regional hospital. (COHS.)

The 1922 building that originally housed the People's Store has recently been completely renovated to its original appearance and now houses Jack Mason's Tavern and the Old Forge Coffee Company, two of Clifton Forge's best places to meet and relax. These establishments provide residents and visitors an important place to gather and socialize and have helped to revitalize business in the commercial district. (COHS.)

Sona Bank, on the left, was originally the new First National Bank. The building was completed in 1965, but the plaza was not completed until the mid-1970s, covering the old open triangle between the bridges. On the right, the Masonic Theater, under the stewardship of the Historic Masonic Theater Foundation, began a complete renovation in 2009. When completed, it will be a first-class entertainment and community-gathering venue. (COHS.)

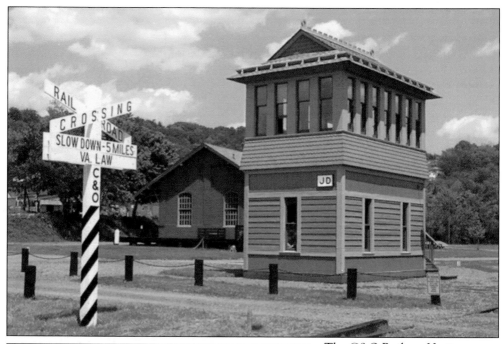

The C&O Railway Heritage Center is located in Smith's Creek Yard, the original site of the C&O Railway in Clifton Forge. It is a premier rail heritage museum, featuring the original 1895 freight house, a replica signal tower and passenger station, a restored 1922 dining car, cabooses, a ride-on train, and more. It is a key component to the development of Clifton Forge as a heritage tourism destination. (COHS.)

The 1898 Pendleton Building now serves as the headquarters and archives of the C&O Historical Society, which located here in 1987. Its mission is to preserve and promote the heritage of the C&O Railway. The society produces a magazine and books, has over 2,500 members worldwide, and houses the largest archives devoted to a single railroad anywhere. The society hosts many events that draw individuals and groups to the community. (COHS.)

Here is the Red Lantern Inn. Once a funeral home, bus station, and doctor's office, this beautifully restored building was derelict as recently as 2009 but is now a showpiece. With seven bedrooms and wonderful, shared spaces for eating and relaxing, it is the only overnight-stay facility in the community. The inn is an example of the new energy and vitality coming into the community and proof that businesses here can be successful. (COHS.)

The Club Car Shop and Deli reopened in the former Farrar's Drugstore in 2003 after extensive remodeling, which included exposing the original terrazzo flooring, adding to the quaint atmosphere in this favorite lunch spot. On the left is the former Rooklin's Clothing Store, which is now the Clifton Forge Antique Mall. The store has an extensive selection of antiques and collectibles. Both of these businesses are mainstays of the modern commercial district. (COHS.)

Discover Thousands of Local History Books
Featuring Millions of Vintage Images

Arcadia Publishing, the leading local history publisher in the United States, is committed to making history accessible and meaningful through publishing books that celebrate and preserve the heritage of America's people and places.

Find more books like this at
www.arcadiapublishing.com

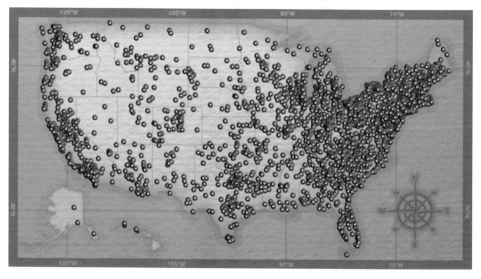

Search for your hometown history, your old stomping grounds, and even your favorite sports team.

Consistent with our mission to preserve history on a local level, this book was printed in South Carolina on American-made paper and manufactured entirely in the United States. Products carrying the accredited Forest Stewardship Council (FSC) label are printed on 100 percent FSC-certified paper.

MADE IN THE USA